STEAM IN THE NORTH EAST
NORTHUMBERLAND, DURHAM & YORKSHIRE

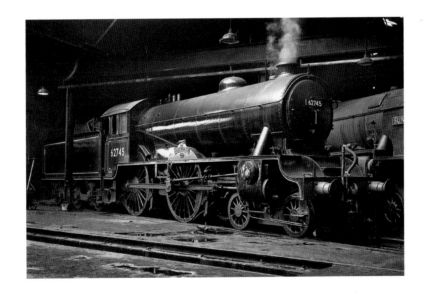

ABOUT THE PHOTOGRAPHER

R.J. (Ron) Buckley was born in 1917 and, after the family moved to a house overlooking Spring Road station, near Tyseley, in 1926, his interest in railways grew. Joining the Birmingham Locomotive Club in 1932, he made frequent trips with them throughout the country, also accompanying W.A. Camwell on his many branch-line tours. From 1936 until 1939, these club tours included visits to north-east England, where he photographed many examples of the pre-grouping locomotive classes still working with both the London & North-Eastern Railway (LNER) and the London, Midland & Scottish Railway (LMS). In 1934 he joined the LMS as a wages clerk at Lawley Street goods station, Birmingham, and, after declaration of war in September 1939, was called up and joined the Royal Engineers, being posted to the No. 4 Dock Operating Unit. Serving briefly in Norway during March 1940, by May of that year he was with a special party supplying stores for the returning troops at Dunkirk. Ron was evacuated from Dunkirk on the *Maid of Orleans*, an ex-Southern Railway (SR) cross-Channel ferry, and by 1941 he was in Egypt with his unit supporting the Eighth Army in its advance from El Alamein, ultimately reaching Tripoli. The year 1944 saw his unit in Alexandria before returning to Britain during 1945 and demobilisation in May 1946. His employment continued with the LMS, being based at Kings Heath in Birmingham and at Derby in the British Railways Divisional Managers Office from 1948. He was a spectator of the continual stream of locomotives passing through the works and photographed many of the new British Railways Standard locomotives constructed there. Further visits to the north-east of England from 1946 to 1949 and throughout the 1950s and 1960s gave him the opportunity to witness the changes that had taken place in locomotive power in the counties of Northumberland, Durham and Yorkshire. Married in 1948 to Joyce, the daughter of an LNER locomotive driver, Ron retired in 1977 after over forty-two years' service with the railways. He and his wife currently live in Staffordshire.

STEAM IN THE NORTH EAST
NORTHUMBERLAND, DURHAM & YORKSHIRE
THE RAILWAY PHOTOGRAPHS OF R.J. (RON) BUCKLEY

COMPILED BY BRIAN J. DICKSON

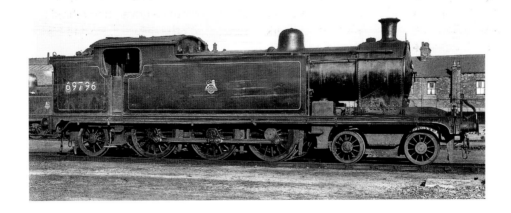

The History Press

ACKNOWLEDGEMENTS

Grateful acknowledgements are due to Colin Stacey of Initial Photographics without who's careful conservation and cataloguing of Ron's negatives this series of books would have been much more difficult to produce. Colin's knowledge of Ron's catalogue has been invaluable in assisting with many captioning details. His guardianship of Ron's negatives is to be commended.

First published 2017

The History Press
The Mill, Brimscombe Port
Stroud, Gloucestershire, GL5 2QG
www.thehistorypress.co.uk

© Brian J. Dickson, 2017

The right of Brian J. Dickson to be identified as the Author
of this work has been asserted in accordance with the
Copyright, Designs and Patents Act 1988.

British Library Cataloguing in Publication Data.
A catalogue record for this book is available from the British Library.

ISBN 978 0 7509 7001 3

Typesetting and origination by The History Press
Printed and bound in Malta by Melita Press

Cover: *Front*: Tuesday 14 August 1956. Class 2 2-6-2 tank No. 41327 is seen at Barnoldswick station. *Back*: Monday 7 August 1939. On holiday in early August 1939, Ron and fellow Birmingham Locomotive Club member, Norman Glover, motored north in an Austin 7, registration number OF1238, visiting the sheds in the north-east of England. This photograph shows ex-NER Class L (LNER Class J73) 0-6-0 tank No. 545 at the Alexandra Dock shed in Hull with Norman sitting in the Austin 7. No. 545 was constructed at Gateshead Works in 1891, as one of only ten locomotives which constituted the first design by Wilson Worsdell for the NER. This powerful class were constructed to work the yards around the River Tyne where they spent many years until the 1930s when they were dispersed to other LNER sheds, the example seen here arriving at Alexandra Dock in 1939. Numbered 68356 by British Railways, she would be withdrawn from service in 1958. The fate of the Austin 7 is unknown.

Half-title: Nigel Gresley's design of express passenger locomotive, intended for more secondary duties within the former NER and North British Railway (NBR) territories, was the three-cylinder Class D49 4-4-0 introduced in 1927, which continued building until 1935 when a total of seventy-six examples had appeared, all coming from Darlington Works. No. 62745 *The Hurworth*, seen here in York shed on Sunday 17 June 1956, was from the 1932 batch of ten locomotives classified D49/2, which were fitted with Lentz Rotary Cam-operated poppet valves. Originally numbered 282 with the LNER, she would be withdrawn in 1959.

Title: Sunday 15 March 1953. Originally constructed as a NER Class W 4-6-0 tank, No. 69796, seen here at Hull Botanic Gardens shed, was rebuilt as a 4-6-2 tank in 1916 and would be classified by the LNER as A6. Numbered 692 by them, she would be withdrawn in 1953.

INTRODUCTION

The three counties of Northumberland, Durham and Yorkshire are linked by the three great industries that grew within their borders, coal, iron and steel and shipbuilding. With huge deposits of coal and limestone in Northumberland and Durham, railways were integral in the growth of these industries from the earliest horse-drawn wooden wagonways for transporting coal to the riverside staithes on the Tyne and Wear, to the inception of the first passenger route between Stockton and Darlington, and finally to the haulage by powerful steam locomotives of imported iron ore from Tyne Dock to the Consett Steel Works. Railways facilitated the growth of the iron and steel industries within Durham and Yorkshire, and similarly the growth of the shipbuilding industry during the nineteenth and early twentieth centuries on the rivers Tyne, Wear and Tees.

The two faces of the old North-Eastern Railway (NER) territory in Northumberland, Durham and Yorkshire were quite distinct, with the main line between Doncaster and Berwick-upon-Tweed being part of the east coast route between Scotland and London, seeing the use of Wilson Worsdell's fleet-footed Class R (LNER Class D20) 4-4-0s and Class V (LNER Class C6) 'Atlantics', and later seeing the introduction of Vincent Raven's impressive Class S3 (LNER Class B16) 4-6-0s. From the mid 1930s, the exciting sight of Nigel Gresley's Class A4 brought improvements to the schedules on this route. Away from the main line, the many collieries and quarries within Northumberland and Durham were served by a variety of ex-NER locomotives, with much of the mineral traffic being handled by the many Class T 0-8-0 locomotives produced by that company. Becoming classes Q5, Q6 and Q7 with the London & North-Eastern Railway (LNER), the majority of the Q6s worked through until the end of main-line steam in the north-east. The NER also owned large numbers of 0-6-0 tank locomotives utilised for general goods haulage, yard work and servicing the many

engineering works and shipbuilding yards within their territory. Many of these tank locomotives remained working until the early 1960s. Passenger traffic on the branch lines and secondary routes was in the hands of the variety of tank locomotives ranging from Wilson Worsdell's Class O (LNER Class G5) 0-4-4s, working rural branches such as Alston, Wearhead and Middleton-in-Teesdale, to his powerful Class W (LNER Class A6) 4-6-2s, handling the coastal traffic from Stockton to Redcar, Saltburn, Whitby and Scarborough.

Having a history just as old as the Durham fields, the coal industry in South Yorkshire stretched from Doncaster northward to Rotherham, Barnsley, Halifax and Leeds, and coal from this field was ideal for the production of gas and coke, with the coke feeding the local iron and steel industries. Railway expansion was rapid; for example, the Middleton Railway in Leeds was the first, created by an Act of Parliament in 1758, to open a horse-drawn wooden wagonway to carry coals into Leeds, later converted to iron rails and steam haulage. Part of the site is still open today as a heritage railway.

The cities and towns of the West Riding of Yorkshire were served by many pre-grouping railway companies, in addition to the NER with the Midland Railway (MR) main line from London to Sheffield, Leeds and the north, and the Great Central Railway (GCR) and its main line from London to Sheffield and Manchester. Both companies also tapped into the huge amounts of traffic generated by the coal, iron and steel industries, with many examples of their locomotives surviving well into the 1950s handling secondary route and branch-line traffic. The 4-4-0 express passenger locomotives of Samuel Johnson design for the MR were still to be seen on much secondary route traffic and many of Henry Fowler's 0-6-0s remained in use. The design work of William Barton Wright and John Aspinall for the Lancashire & Yorkshire Railway (L&YR) could still be seen in the form of many 0-6-0 tender and tank locomotives

handling goods traffic and working in goods yards. Also, prior to the introduction of diesel multiple units (DMU), several of the branch lines in the area still utilised Railmotor or push-pull formations with ex-L&YR 2-4-2 tank locomotives providing the motive power.

Ron Buckley's photographs show the changes in the locomotive scene taking place throughout the counties of Northumberland, Durham and Yorkshire, illustrating, from the later 1930s, those pre-grouping classes that were still working. These included the work of such well-known locomotive designers as Wilson Worsdell and Vincent Raven of the NER, and Henry Ivatt and Nigel Gresley of the Great Northern Railway (GNR). Also seen were the works of William Barton Wright and John Aspinall of the L&YR, and Samuel Johnson and Henry Fowler of the MR. Ron's later photographs, from 1946 on, show some more of these remaining working pre-grouping locomotives and additionally portray the newer designs of William Stanier, Charles Fairburn, Edward Thompson and Arthur Peppercorn, together with examples of the British Railways Standard locomotives designed under the leadership of Robert Riddles.

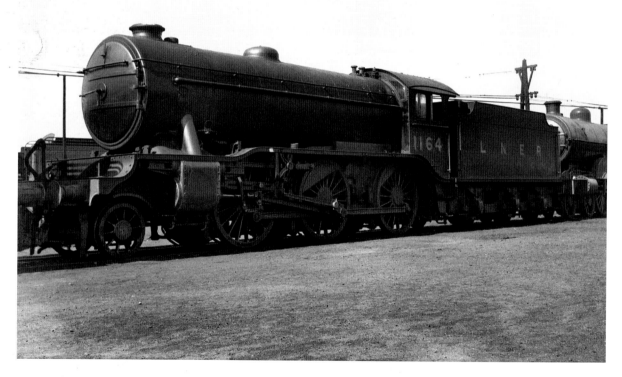

Sunday 10 May 1936 Ex-LNER Class K3 2-6-0 No. 1164 is seen standing in the yard at Doncaster shed. Constructed by Armstrong Whitworth during 1931, she would be withdrawn in 1962 numbered 61917 by British Railways.

Saturday 30 May 1936 A comparison of two early MR, Samuel Johnson-designed 4-4-0s, both seen at Hellifield. *Top:* Derby Works-built Class 2 (LMS Class 2P) No. 547 entered service in 1901 and would be rebuilt with different boilers in 1906 and again in 1914. She would survive to become No. 40547 with British Railways and be withdrawn in 1953. *Bottom:* Class 2606 (LMS Class 3P) No. 777 is seen at the head of a 'down' stopper that consists of three ancient-looking vehicles, the first of which is a six-wheeler. Constructed at Derby Works during 1905, this locomotive would be withdrawn in 1939.

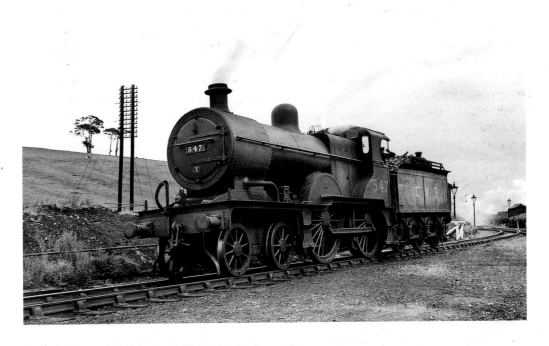

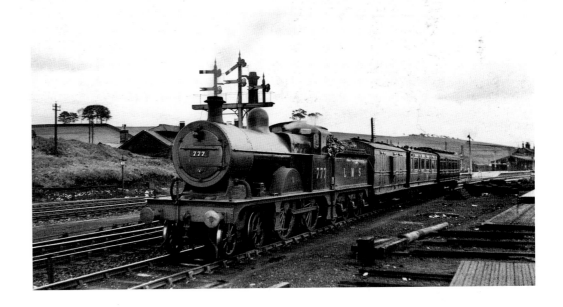

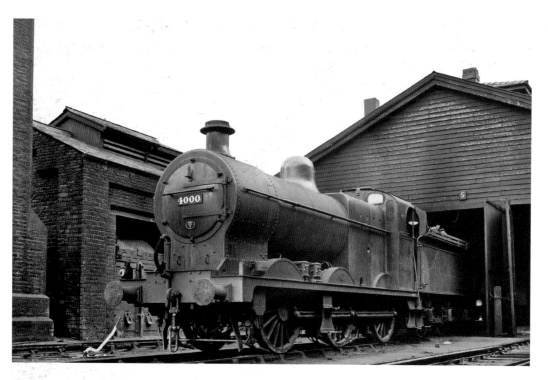

Saturday 30 May 1936 Sitting adjacent to Skipton shed is ex-MR Class 3835 (LMS Class 4F) 0-6-0 No. 4000. Bearing a Skipton shed code of 20F, and seen here fitted with a weatherboard tender for extra crew protection, she was a product of Derby Works during 1921. The class was introduced in 1911 to a design of Henry Fowler, with nearly 200 examples being constructed at both Derby Works and Armstrong Whitworth. The example seen here would be withdrawn in 1959.

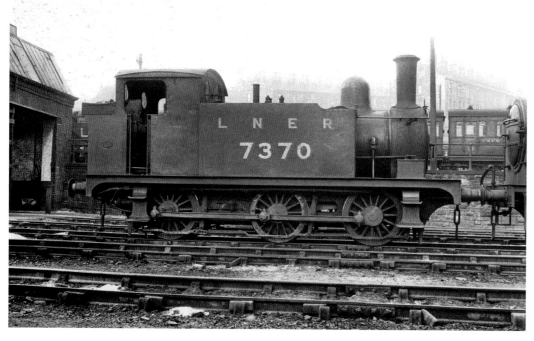

Sunday 6 June 1937 Parked outside the shed at Ardsley is ex-Great Eastern Railway (GER) Class R24 (LNER Class J69/1) 0-6-0 tank No. 7370. Originally constructed at Stratford Works in 1894, she would be rebuilt in 1904 and manage to give sixty-four years' service before withdrawal in 1958 numbered 68546. Designed by James Holden primarily to handle suburban passenger trains, many examples ended their days shunting in goods yards.

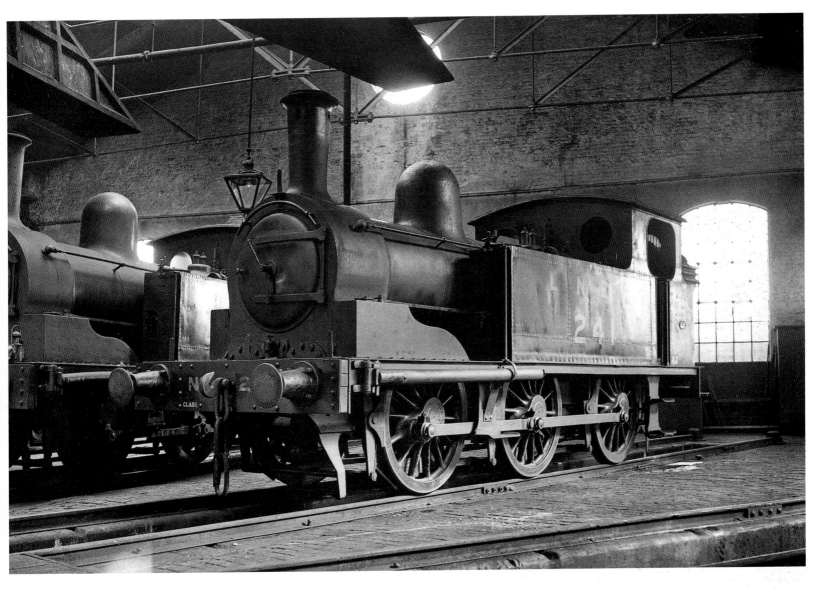

Sunday 15 August 1937 Photographed inside West Auckland shed is ex-NER Class E (LNER Class J71) 0-6-0 tank No. 241. Designed by Wilson Worsdell's older brother, Thomas, and introduced during 1886, the example seen here was constructed at Darlington Works in 1890 and one of the very few of the class fitted with shunting poles. These wooden poles fitted on hinged brackets swung outwards, enabling the shunting of wagons on adjacent lines. This locomotive would be withdrawn in 1952 numbered 68255.

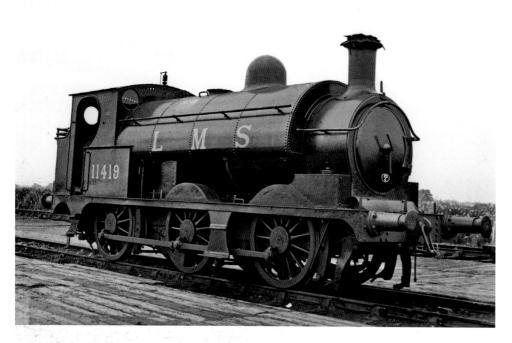

Sunday 17 July 1938 The two locomotives seen here were both originally constructed as Class 528 0-6-0 tender locomotives designed by William Barton Wright for the L&YR and introduced in 1876. Both were rebuilt at Horwich Works between 1891 and 1900, during the John Aspinall period at the L&YR, to appear as Class 23 (LMS Class 2F) 0-6-0 saddle tanks. *Top:* No. 11419 was constructed by Kitson & Co. in 1880 and is seen here at her home shed of Goole, bearing the correct 25C shed code. She would be withdrawn during 1961 numbered 51419 by British Railways. *Bottom:* No. 11358 was another Kitson & Co.-built example of the class, entering service during 1878 and seen here at Wakefield shed. Numbered 51358 with British Railways, she would be withdrawn in 1959. Both these locomotives would each give eighty-one years' service.

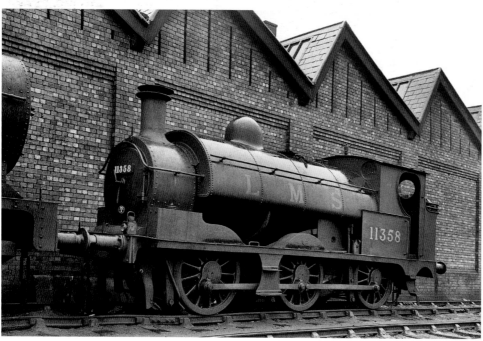

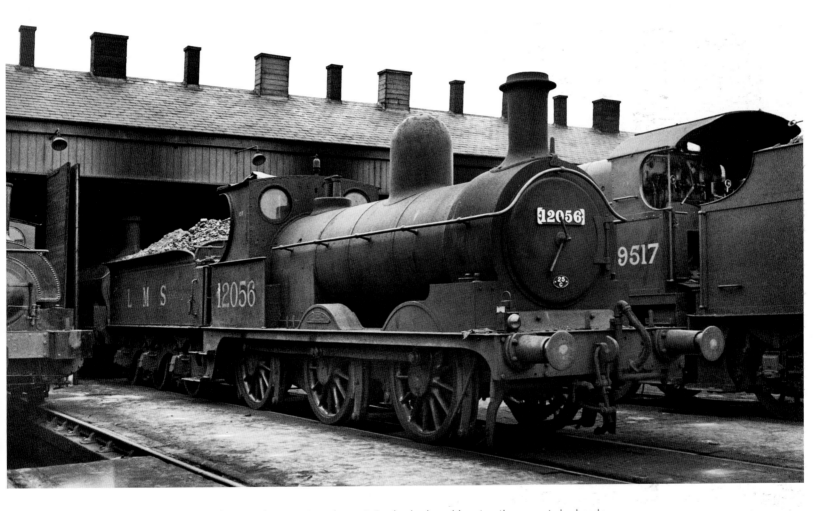

Sunday 17 July 1938 Seen here at Goole shed, and bearing the correct shed code 25C, is ex-L&YR Class 928 (LMS Class 2F) 0-6-0 No. 12056. Constructed by Beyer Peacock & Co. in 1887 to a design by William Barton Wright, she would be withdrawn after sixty-three years' service in 1951, numbered 52056.

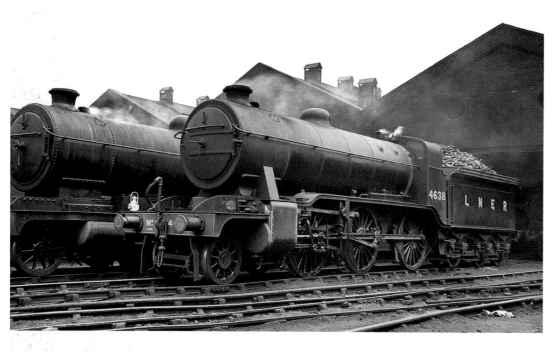

Sunday 17 July 1938 Standing among the smoky atmospherics of Mexborough shed is LNER Class K2 2-6-0 No. 4638. Originally built as part of Nigel Gresley's first design for the Great Northern Railway (GNR) at Doncaster Works in 1913, classified H2 by the GNR and later classified K1 by the LNER, she would be rebuilt as a Class K2 in 1936. Numbered 61728 by British Railways, she would be withdrawn in 1960.

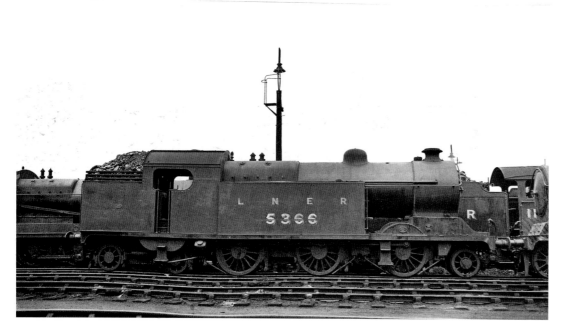

Sunday 17 July 1938 The impressive bulk of ex-GCR Class 1B (LNER Class L1 later L3) 2-6-4 tank No. 5366 is clearly seen here at Mexborough shed. Designed by John Robinson primarily to haul goods traffic and constructed at Gorton Works in 1914, by July 1938 she was undertaking banking duties. She would be withdrawn from service in 1954 numbered 69065. This class constituted the first of this wheel arrangement to work in Great Britain.

Sunday 2 April 1939 Another locomotive class with presence was the extremely powerful three-cylindered ex-NER Class T3 0-8-0, of which only five were initially constructed. Designed by Vincent Raven, a further ten examples were built during 1924 by the LNER, by which time they had become Class Q7 locomotives. Seen here in Darlington Works yard after an overhaul and looking in sparkling condition is No. 626, constructed at the same works as part of the 1924 batch. Initially allocated to Hull shed, by the 1940s she would, with the rest of her class, be allocated to Tyne Dock shed primarily to handle the iron-ore traffic to the steel works at Consett. Later numbered 63467, she would be withdrawn toward the end of 1962. Fortunately, one locomotive from the class managed to reach the preservation scene – No. 63460 is based at the North York Moors Railway.

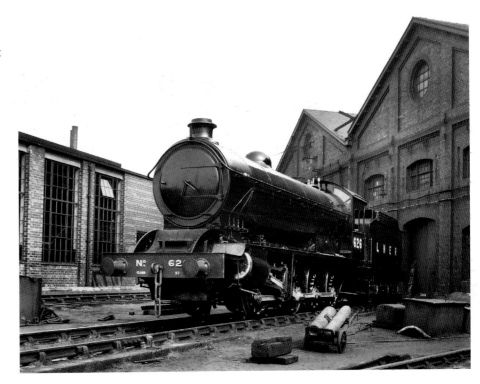

Sunday 2 April 1939 Another ex-works locomotive seen here in Darlington Works yard is ex-NER Class P2 (LNER Class J26) 0-6-0 No. 132. Designed by Wilson Worsdell and constructed at the same works in 1904, she would be rebuilt in 1916 with a slightly larger Class P3 boiler. The first of the class to enter service, she would be withdrawn numbered 65730 by British Railways in 1959.

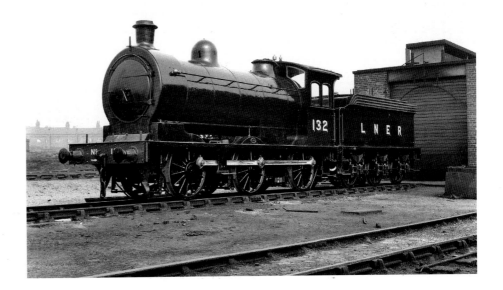

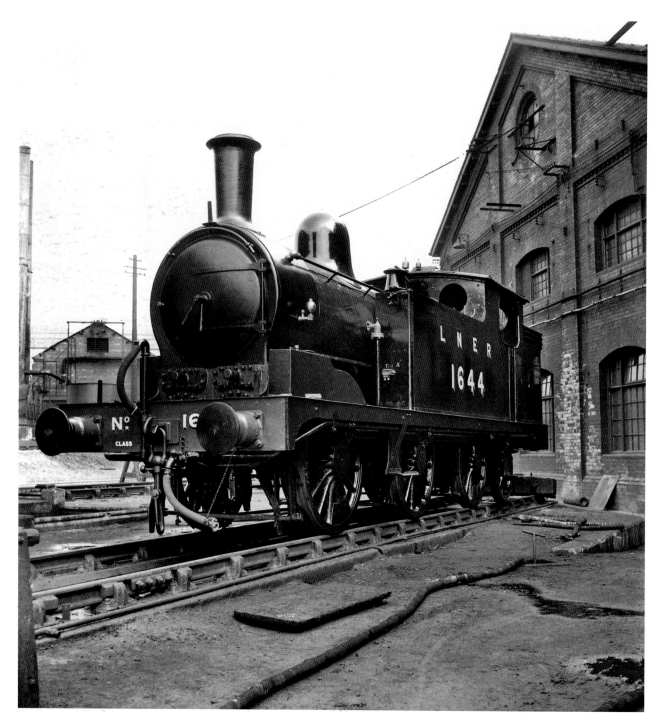

Sunday 2 April 1939 Standing in the yard at Darlington Works is ex-NER Class N (LNER Class N9) 0-6-2 tank No. 1644. In sparkling ex-works condition, she was at this time allocated to Tyne Dock shed. Constructed at the same works in 1893 as part of a class of only twenty examples to a design by Wilson Worsdell, she would later be numbered 9416 by the LNER and withdrawn just before Nationalisation in late 1947.

Sunday 2 April 1939 Vincent Raven's design of a three-cylinder 4-6-0 mixed-traffic locomotive, the NER Class S3 (LNER Class B16), was introduced in 1919, with thirty-eight examples being constructed prior to the grouping and an additional thirty-two appearing during LNER days in 1923 and 1924. Seen here in Darlington Works yard is No. 928, a product of the same works in 1921. She would be numbered 61423 by British Railways and withdrawn in 1961.

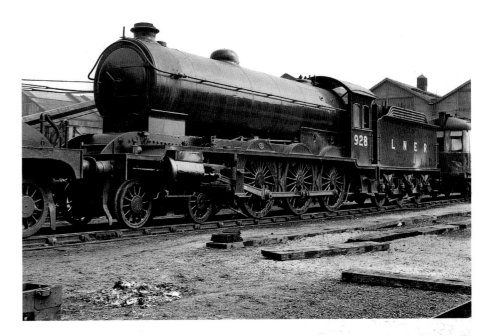

Sunday 2 April 1939 Standing in the yard at Darlington Works is ex-NER Class O (LNER Class G5) 0-4-4 tank No. 2085. Another Wilson Worsdell design introduced in 1894, a total of 110 examples of this very useful passenger tank locomotive would be constructed at these works, with the final member of the class appearing in 1901. The locomotive seen here was from a 1900-built batch that would survive to become No. 67314 with British Railways and be withdrawn in 1955.

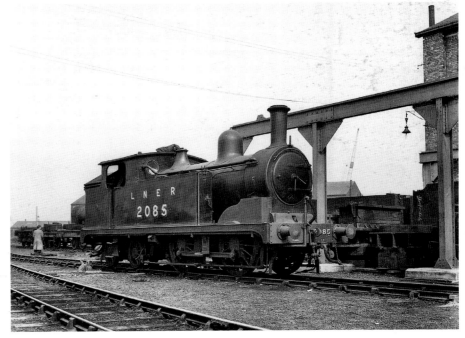

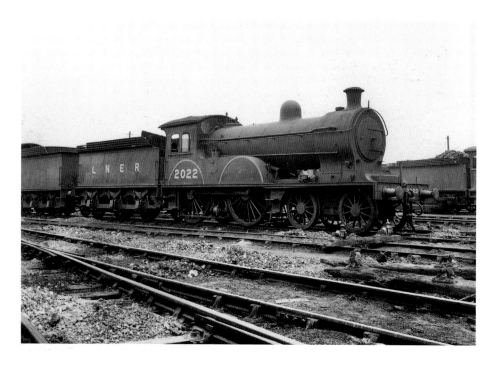

Sunday 2 April 1939 Seen here in the yard at Darlington shed is ex-NER Class R (LNER Class D20) 4-4-0 No. 2022. A product of Gateshead Works in 1900, she would be fitted with a superheating boiler in 1913 and become one of the last withdrawals of the class, coming out of service in 1954 numbered 62351.

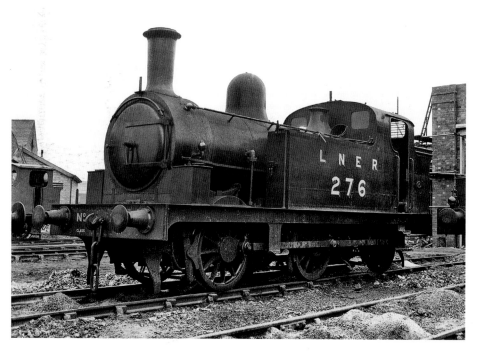

Sunday 2 April 1939 Something of a veteran is seen here in Darlington shed yard. Ex-NER Class 290 (LNER Class J77) 0-6-0 tank No. 276 was originally constructed as a 0-4-4 well tank to a design by Edward Fletcher and was introduced in 1874. The example here was built at Gateshead Works in 1878 and rebuilt as a 0-6-0 tank during the Wilson Worsdell period in 1901 at York Works. She was destined to see service for seventy-six years before withdrawal numbered 68421 in 1954.

Sunday 2 April 1939 Very much a reminder of an earlier age, the 2-4-0 wheel arrangement of the ex-GER Class T26 (LNER Class E4) is seen here with locomotive No. 7463 at Darlington shed. A number of this class became the last working examples of this wheel arrangement in Great Britain, with No. 7463 being withdrawn in 1956 as No. 62781. Constructed at Stratford Works in 1892 to a design by James Holden, in 1936 she would be one of only six members of the class to be fitted with a larger cab, as seen here.

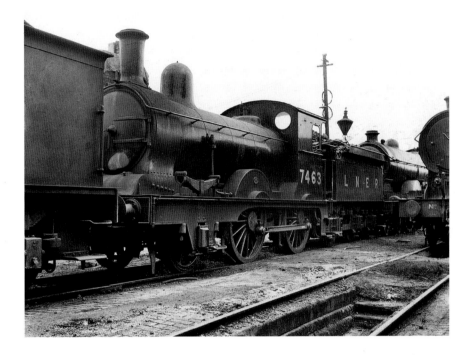

Sunday 2 April 1939 Originally constructed at Darlington Works as a three-cylinder Class H1 4-4-4 tank by the NER in 1922, No. 1500, seen here at Middlesbrough shed, was rebuilt during 1934 as a 4-6-2 tank and classified A8 by the LNER. The 4-4-4s were found to be rather lacking in adhesion and their rebuilding to 4-6-2s led them to be more sure-footed. No. 1500 would be numbered 69879 with British Railways and was withdrawn in 1958.

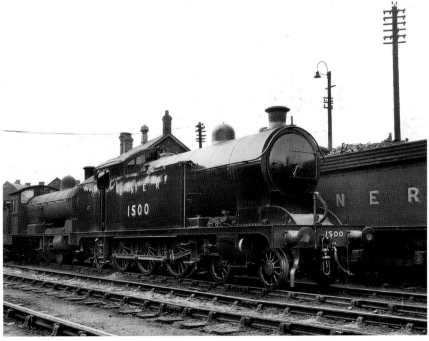

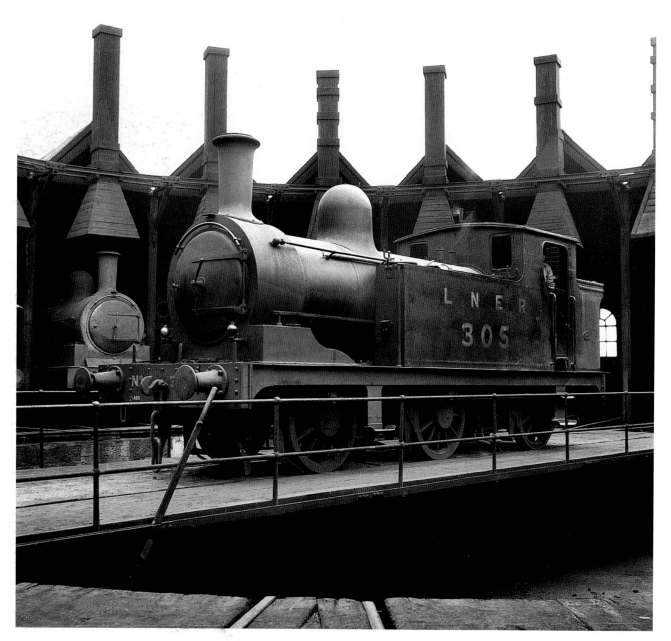

Sunday 2 April 1939
Ex-NER Class 290 (LNER Class J77) 0-6-0 tank No. 305 is seen posed on the turntable at Middlesbrough shed. Originally constructed as a 0-4-4 well tank at York Works in 1884, she was rebuilt in 1899, again at York Works, as a 0-6-0 tank. She would be withdrawn, numbered 8441 by the LNER, in 1948. The splendid roundhouse building seen in the background was so badly damaged during the Second World War that it would be demolished and afterwards the locomotives would be stabled in the open.

Sunday 2 April 1939 Seen here at Middlesbrough shed is ex-NER Class T1 (LNER Class Q5) 0-8-0 No. 1320. A total of ninety locomotives were constructed to this design of Wilson Worsdell, of which fifty came out of Gateshead Works between 1901 and 1904, with a further forty being built at Darlington Works between 1907 and 1911. Forty examples of the Gateshead locomotives were fitted with piston valves and classified T, with the remaining locomotives all having slide valves and classified T1. No. 1320 was constructed at Gateshead Works in 1902 and she would be withdrawn in 1948, numbered 3262 by the LNER. The fifty slide-valve locomotives were loaned to the Railway Operating Division (ROD) during the First World War and, in recognition of their service in France, bore the Royal Engineers flaming grenade emblem with three chevrons. This can be seen on the leading sandbox of this locomotive.

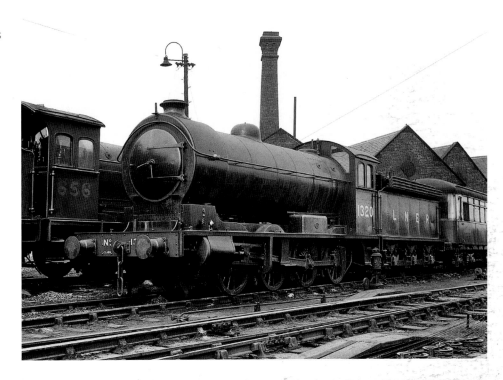

Sunday 2 April 1939 Introduced in 1926 by the LNER, Nigel Gresley's design of 0-6-0 Class J39 was a powerful workhorse, with a total of 289 being constructed between 1926 and 1941. Seen here at Haverton Hill shed is No. 1459, one of the earliest members of the class built at Darlington Works in 1926. She would be withdrawn numbered 64710 in 1961.

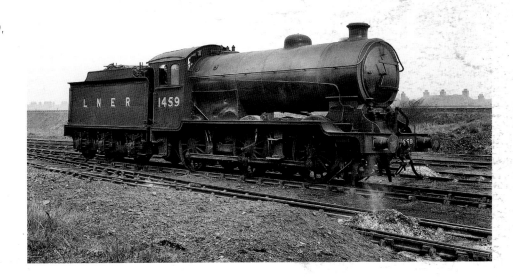

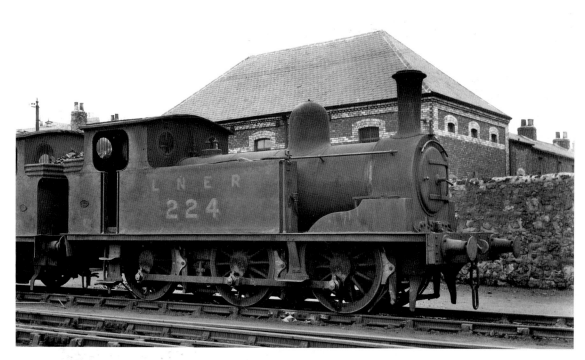

Sunday 2 April 1939 Thomas Worsdell's design of 0-6-0 tank locomotive, NER Class E, was introduced in 1886 and continued building until 1895, with a total of 119 examples all being constructed at Darlington Works. Classified J71 by the LNER, the three examples shown here, all photographed at West Hartlepool shed, are *(left, top)* No. 224, built in 1889, becoming No. 68248 with British Railways and being withdrawn in 1951; *(left, bottom)* No. 1151, constructed in 1892 and withdrawn in 1956 numbered 68291; and *(opposite)* No. 450, also constructed in 1892. She would become No. 68276 with British Railways and withdrawn in 1956.

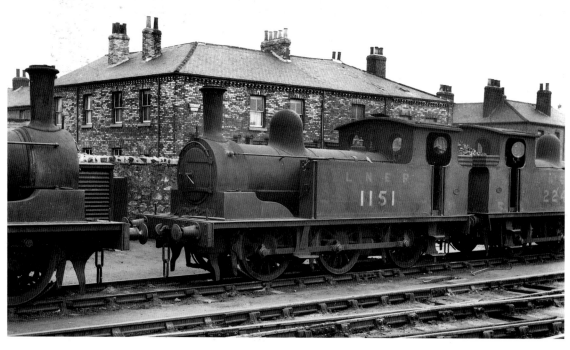

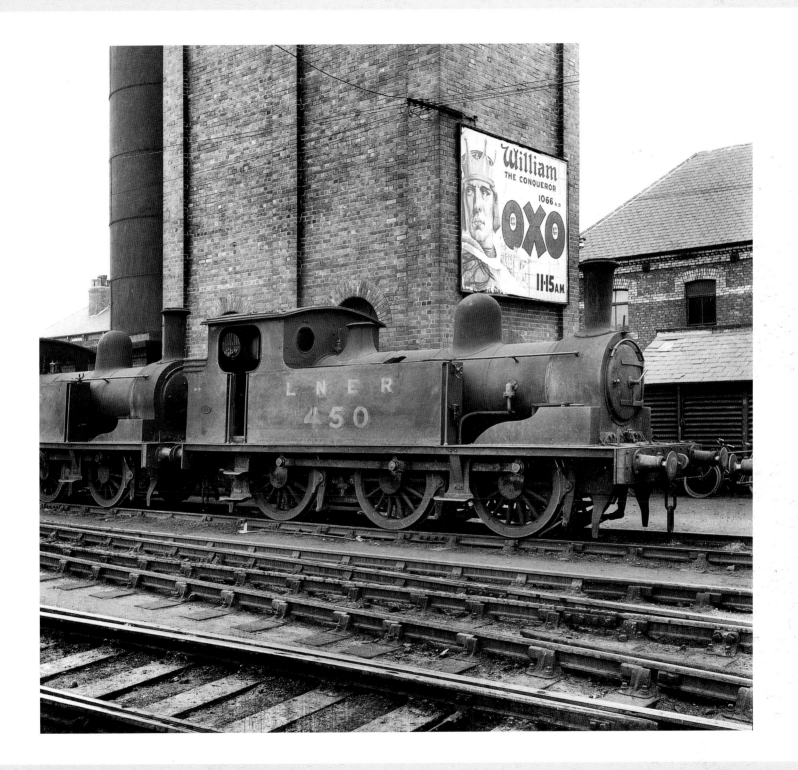

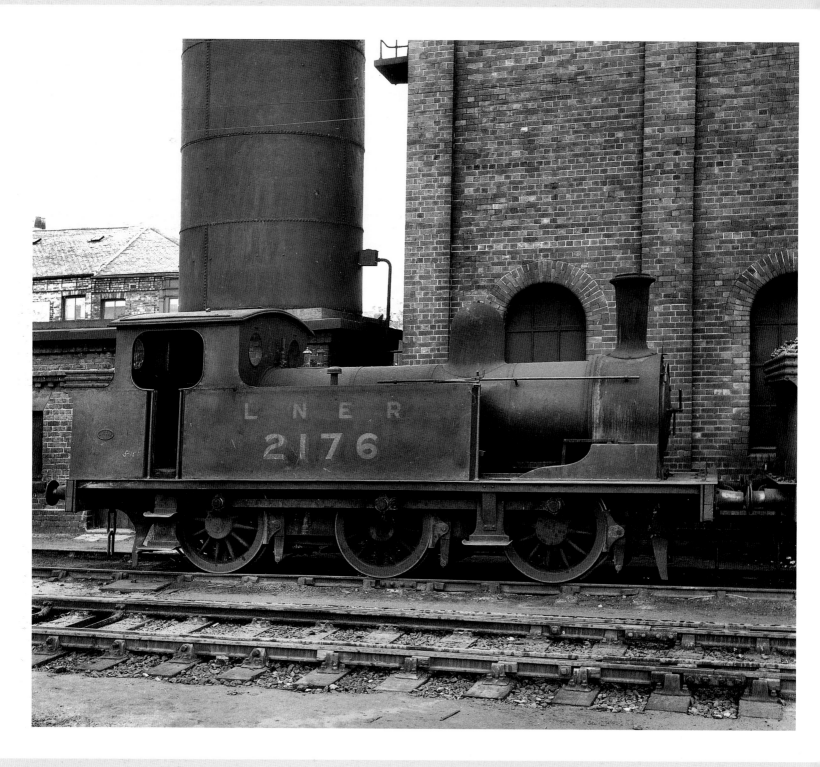

(Opposite) Sunday 2 April 1939 The construction of 0-6-0 tank locomotives for shunting purposes was continued by Wilson Worsdell when he succeeded to the post of Locomotive Superintendent in 1890. His Class E1 (LNER Class J72) bore all the same characteristics as his brother Thomas' Class E, except for the use of larger cylinders. Seen here at West Hartlepool shed is No. 2176, constructed in 1914 at Darlington Works. She would be withdrawn in 1961 numbered 68693.

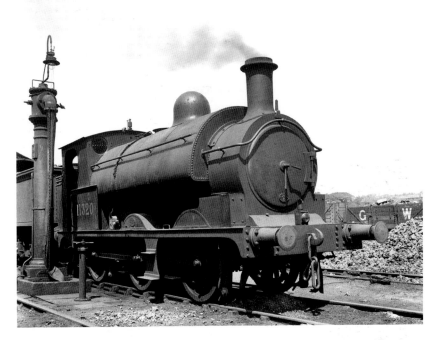

Thursday 1 June 1939 Another of the L&YR Class 23 0-6-0 saddle tanks rebuilt from Class 528 0-6-0 tender locomotives is seen here at Mirfield shed. No. 11320 was originally constructed by Sharp Stewart & Co. in 1877 and would be rebuilt during the John Aspinall period. She would be withdrawn in 1948, having served for fifty years.

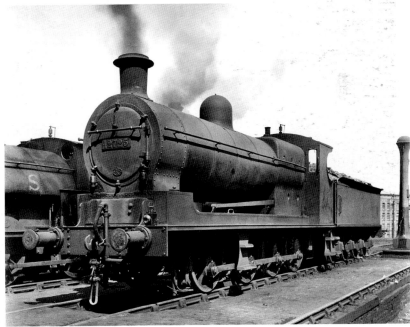

Thursday 1 June 1939 The powerful locomotive seen here at Sowerby Bridge shed is ex-L&YR Class 30 (LMS Class 5F) 0-8-0 No. 12725. Designed by John Aspinall and introduced in 1900, the example here was constructed at Horwich Works in 1902 and would be withdrawn from service in 1946.

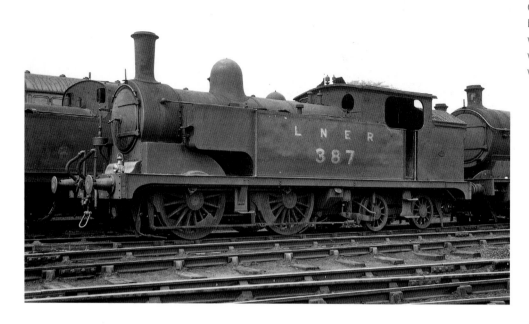

Sunday 6 August 1939 Ex-NER Class O (LNER Class G5) 0-4-4 tank is seen here at Starbeck shed. Built at Darlington Works in 1901, uniquely she would be fitted with extended water tanks, as seen here in 1938, and with push-pull equipment early in 1939. Numbered 67340 with British Railways, she would be withdrawn in 1958.

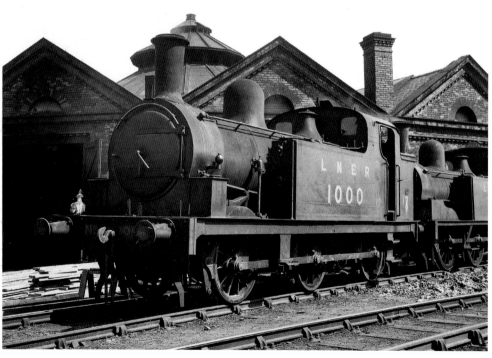

Sunday 6 August 1939 A further example of Wilson Worsdell's rebuilding of Edward Fletcher's design of 0-4-4 well tanks into a 0-6-0 tank is seen here at York shed. No. 1000 had originally been constructed at Gateshead Works in 1880 and would be rebuilt at York Works in 1900 as a Class 290 0-6-0 tank. Later classified J77 by the LNER, the locomotive seen here would be withdrawn in 1951.

Sunday 6 August 1939 Seen here at Selby shed is ex-NER Class R (LNER Class D20) 4-4-0 No. 1258, a member of a class of express passenger locomotives constructed at Gateshead Works between 1899 and 1907 to a design by Wilson Worsdell. She was built in 1907 and would be fitted with a superheating boiler in 1917. Not destined to become part of the British Railways fleet, she was withdrawn in 1946.

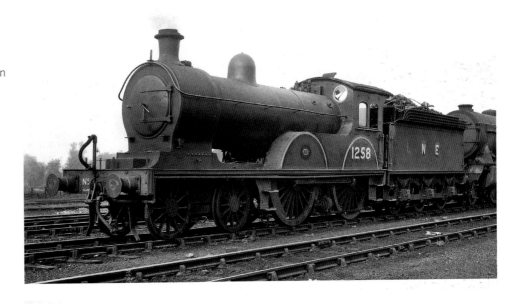

Sunday 6 August 1939 Seen here four months after the photograph on p. 13, ex-NER Class T3 (LNER Class Q7) 0-8-0 No. 626 is looking work-stained while standing in the yard at Selby shed.

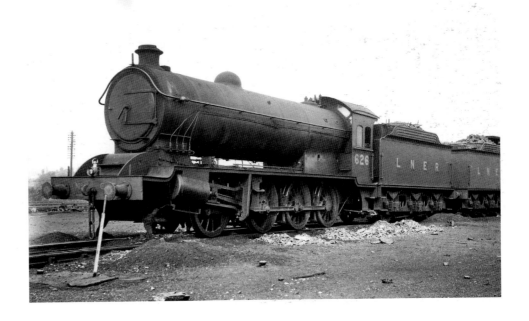

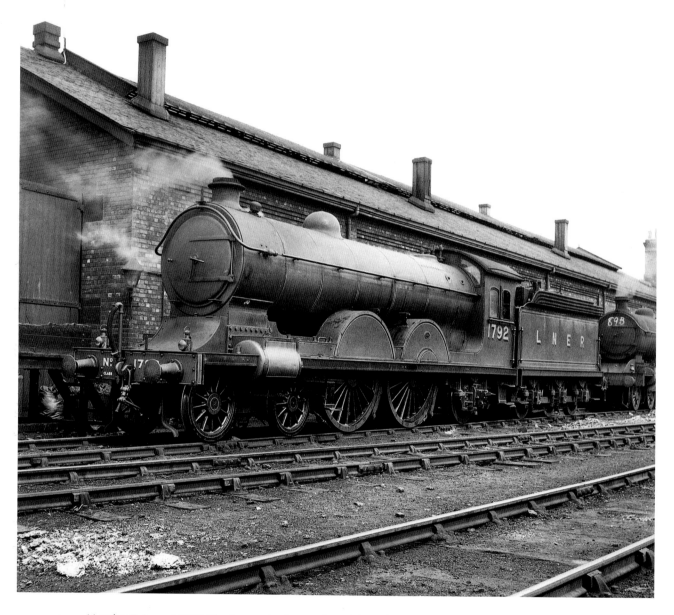

Monday 7 August 1939 The impressive locomotive with its distinctive LNER green livery, seen here at Bridlington shed, is ex-NER Class V (LNER Class C6) 4-4-2 No. 1792. Designed by Wilson Worsdell specifically to handle the heavy express passenger traffic to Scotland, the first ten examples were constructed at Gateshead Works during 1903 and 1904, with the locomotive seen here being a 1904 example. Fitted with a superheating boiler in 1915, she would be withdrawn in 1948.

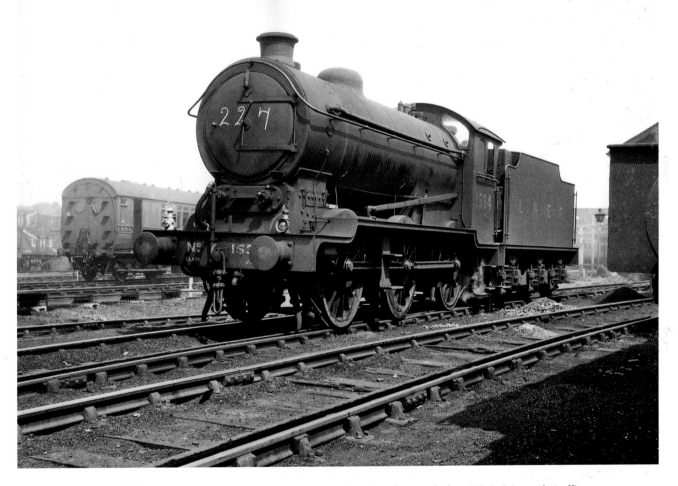

Monday 7 August 1939 After completion of the Nigel Gresley-designed Class J38 0-6-0 goods traffic locomotives in 1926, the subsequent class of 0-6-0 goods locomotives were equipped with larger 5ft 2in driving wheels and classified J39. Delivery commenced from Darlington Works later in 1926, with a total of 289 examples entering service, the last during 1941. Beyer Peacock & Co. supplied twenty-eight examples in 1936 and 1937, and seen here in Bridlington shed yard is No. 1534, a 1936 Beyer Peacock-built example that would be numbered 64916 with British Railways and withdrawn in 1961.

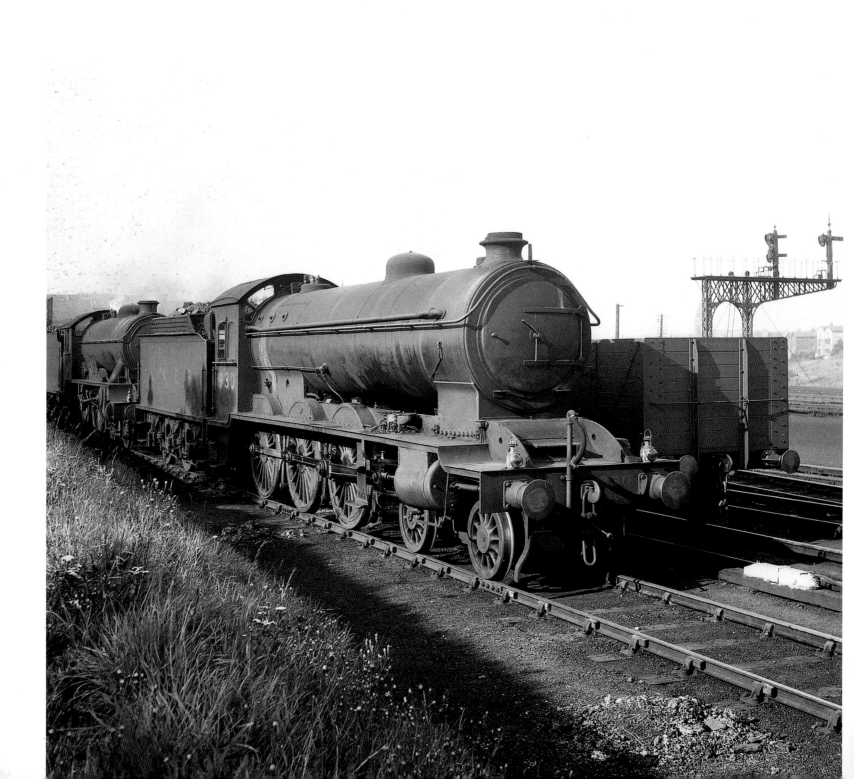

(Opposite) Monday 7 August 1939 Seen here at Scarborough shed is ex-NER Class S3 (LNER Class B16) 4-6-0 No. 930. Constructed at Darlington Works in 1921, she would give forty years' service before withdrawal in 1961 numbered 61425.

Monday 7 August 1939 Another graceful-looking Wilson Worsdell design of 4-4-0 express passenger locomotives were the NER Classes M1 and Q, classified D17/1 and D17/2 by the LNER. No. 1902, seen here at Scarborough shed, was an 1897 product of Gateshead Works that fell into the Class Q (LNER Class D17/2) category. Originally constructed with slide valves, she would be rebuilt with piston valves and a superheating boiler in 1919. The locomotive here would be one of the last examples of the class to be withdrawn in 1948.

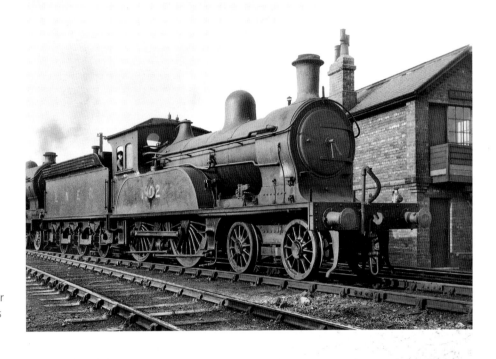

Monday 7 August 1939 Another 'Atlantic' seen and photographed on this day, this time at Scarborough shed, was ex-NER Class V/09 (LNER Class C6) No. 701. Seen standing beside classmate No. 704, they were both products of Darlington Works in 1910. No. 701 would be withdrawn in 1944 with No. 704 following in 1947.

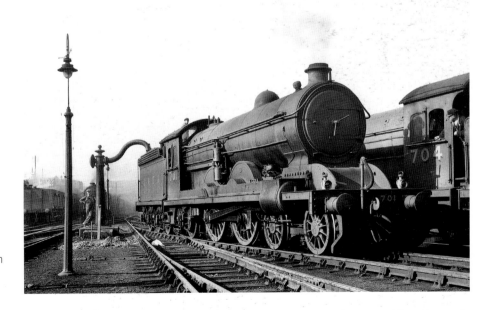

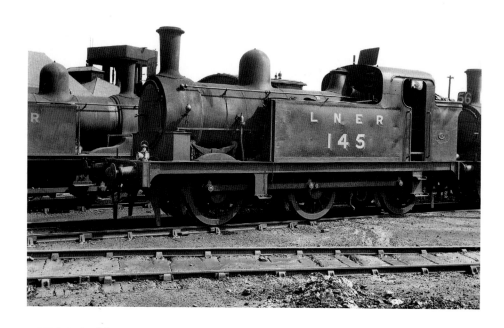

Monday 7 August 1939 Ex-NER Class 290 (LNER Class J77) 0-6-0 tank No. 145 is parked in the yard at the Alexandra Dock shed, Hull. Another of the rebuilds of an earlier class of 0-4-4 well tanks, she was originally constructed at York Works in 1878, rebuilt at York Works in 1904 and withdrawn after sixty-eight years' service in 1946, numbered 8419 by the LNER.

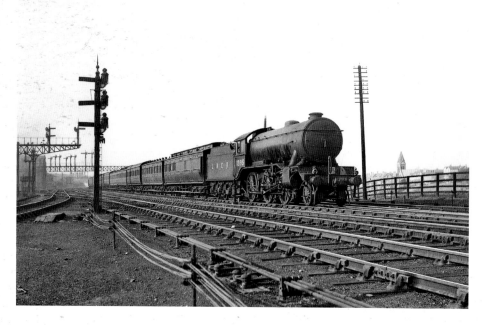

Monday 7 August 1939 Seen passing Scarborough shed with an 'up' express is LNER Class K3/3 2-6-0 No. 1395. Designed by Nigel Gresley and introduced by the GNR as Class H4 in 1920, a total of 193 examples of the class were constructed by both Doncaster and Darlington Works, together with Armstrong Whitworth and Robert Stephenson & Co. Classified K3 by the LNER, the last example appeared during 1937. The locomotive seen here was a Doncaster Works product of 1929 that would be numbered 61886 by British Railways and withdrawn in 1962.

(Opposite) Monday 7 August 1939 The wonderful spectacle seen here is ex-NER Class R (LNER Class D20) 4-4-0 No. 1234 pounding past Scarborough shed at the head of an 'up' express. Designed by Wilson Worsdell and introduced in 1899, a total of sixty examples were constructed in batches up to 1907, all coming from the Gateshead Works of the NER. Built with saturated boilers, they would be rebuilt between 1912 and 1925 with superheating boilers that would improve their performance. The example seen here was from the 1907 batch, which would become one of the early class withdrawals after only thirty-six years' service in 1943.

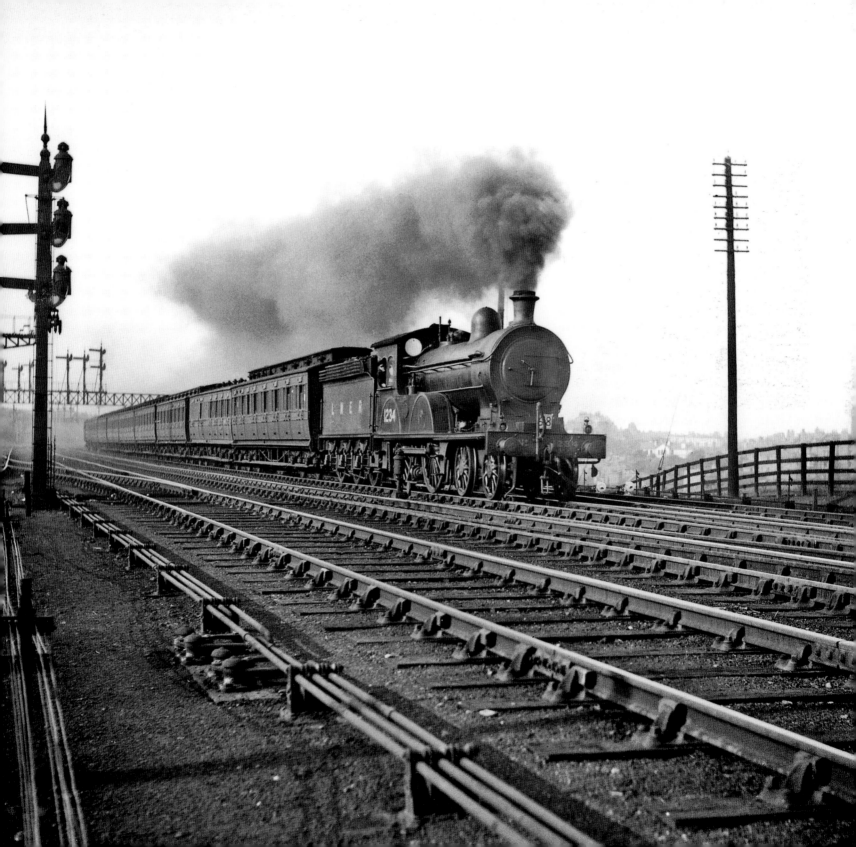

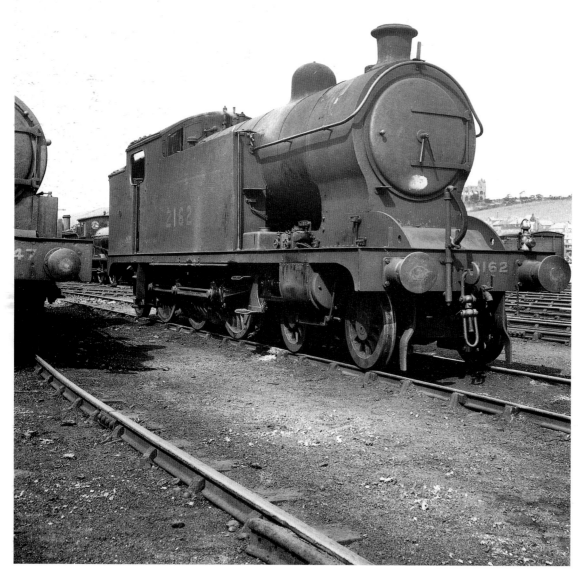

Tuesday 8 August 1939 Parked in the yard at Whitby shed is LNER Class A8 4-6-2 tank No. 2162. Originally constructed at Darlington Works in 1914 to a design of Vincent Raven as a three-cylinder Class H1 4-4-4 tank, she would be rebuilt at Darlington in 1931. The first of the class to be rebuilt in this way, the remaining forty-four examples would follow between 1933 and 1936. She would be withdrawn in 1960 after being numbered 69869 by British Railways.

Tuesday 8 August 1939 Wilson Worsdell's design of Class P 0-6-0 was introduced to the NER in 1894, with a total of seventy examples being constructed at both Gateshead and Darlington Works, the final locomotive appearing in 1898. They were classified J24 by the LNER and seen here at Whitby shed is No. 1850, a Gateshead-built example from 1895 that would later be numbered 5612 by the LNER and withdrawn during 1948.

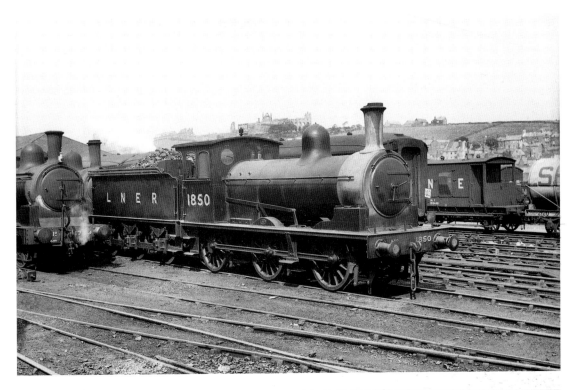

Wednesday 9 August 1939 The LNER purchased a total of eighty steam railcars between 1925 and 1932, with a large number of them being allocated to sheds in north-east England. Seen as a way of reducing operating costs on lightly used lines, they proved to be moderately successful with these operations. Seen here at Whitby is six-cylinder, 100hp railcar No. 2152 *Courrier*, constructed by the Sentinel-Cammell consortium in 1928. She would be withdrawn from service in 1943.

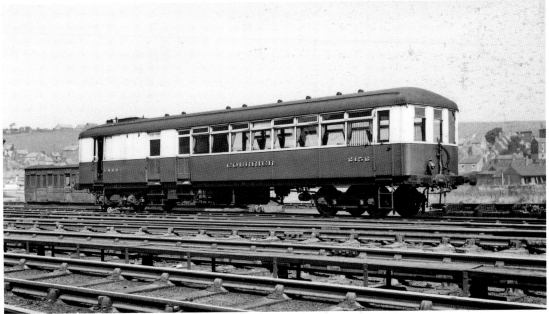

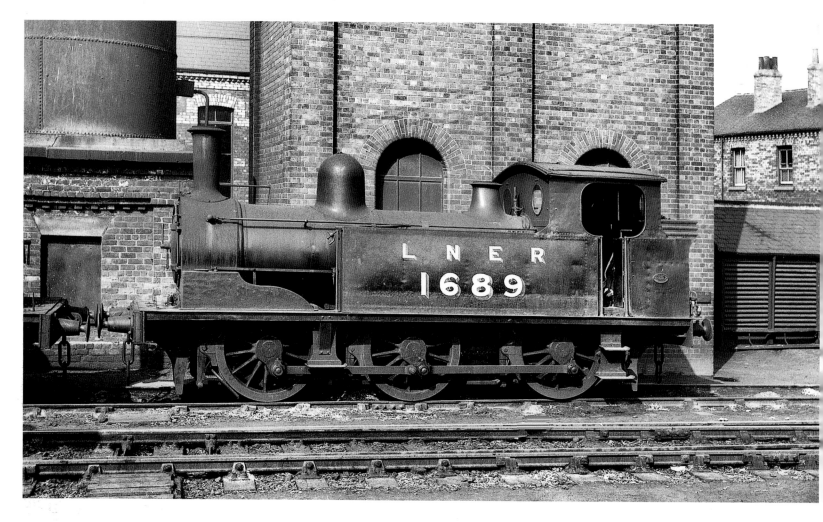

Wednesday 9 August 1939 Seen here at West Hartlepool shed is one of the last built ex-NER Class E (LNER Class J71) 0-6-0 tanks, No. 1689, coming from Darlington Works in 1895. She would be numbered 68313 and withdrawn after sixty-one years' service in 1956.

(Opposite) Wednesday 9 August 1939 The diminutive locomotive seen here parked inside Tyne Dock shed is ex-NER Class H (LNER Class Y7) 0-4-0 tank No. 986. Designed by Thomas Worsdell and introduced in 1888, nineteen examples were constructed at Darlington Works in three batches in 1888, 1891 and 1897. A further five examples were constructed, also at Darlington, during the post-grouping period in 1923. Basically designed as a small yard or dock shunter, No. 986 would also see service briefly with the North Sunderland Railway between Chathill and Seahouses. An example of the 1923-built batch, No. 986 was at one time fitted with shunting poles: the brackets can be seen here fitted to the locomotive. She would become No. 68089 with British Railways and withdrawn from their service early in 1952 to be sold into the industrial scene and finally scrapped in 1955.

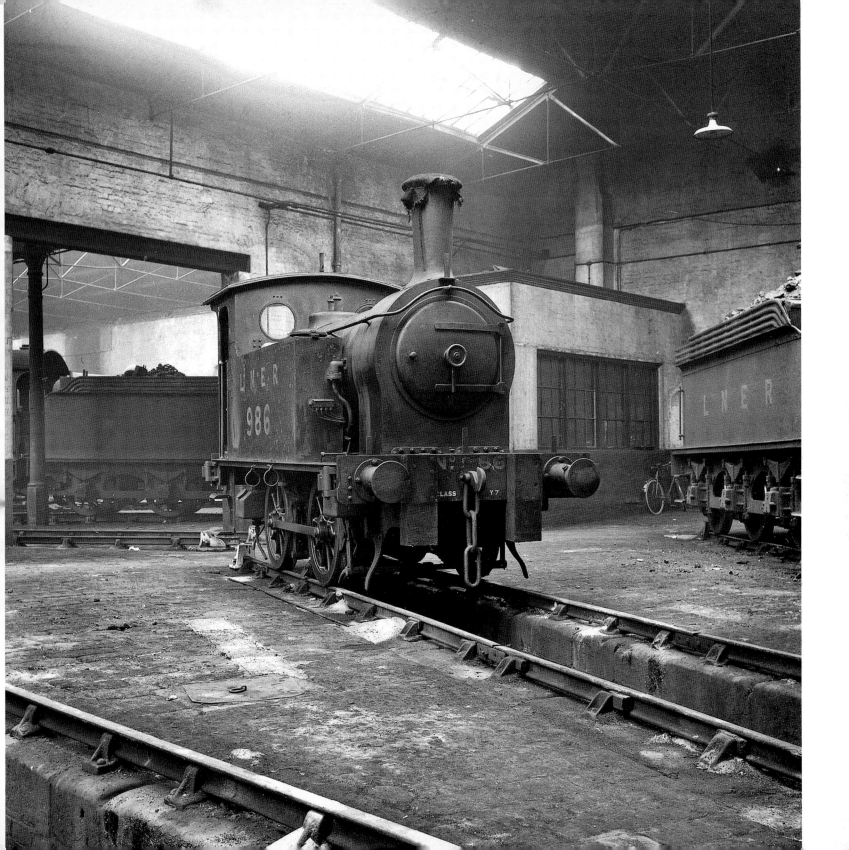

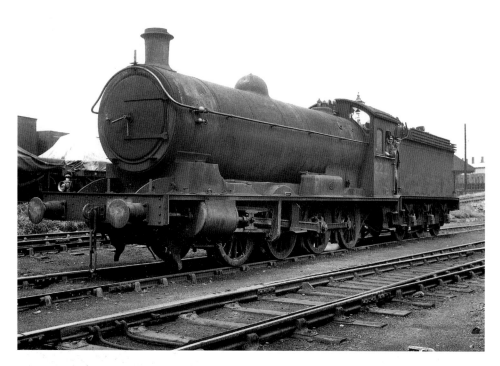

Wednesday 9 August 1939 With the need for more powerful mineral locomotives, Vincent Raven produced a design for a superheated, piston-valve-fitted 0-8-0 for the NER, with the first members of the Class T2 (LNER Class Q6) appearing from Darlington Works in 1913. By 1921 a total of 120 had been constructed. Seen here at the Borough Gardens shed in Gateshead is No. 2227. Built in 1917, she would be numbered 63384 and withdrawn in 1966.

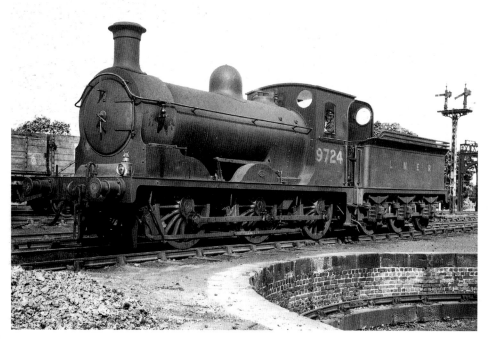

Thursday 10 August 1939 Bathed in summer sunshine while standing adjacent to the turntable at Hexham shed is ex-Northern British Railway (NBR) Class C (LNER Class J36) 0-6-0 No. 9724. Having worked on the border counties route from Riccarton and Reedsmouth, she is ready to work back again later in the day. Built at Cowlairs Works in 1897 to a design by Matthew Holmes, she would be rebuilt by the NBR in 1919 in the form seen here. Numbered 65295 by British Railways, she would give sixty-four years' service before withdrawal in 1961.

(Opposite) Thursday 10 August 1939 In good clean condition, Sentinel-built LNER Class Y1 No. 150 is seen in the yard at Hexham shed. Following the testing of a Sentinel locomotive in 1925, the LNER purchased a total of fifty-six examples over a period of eight years. Found to be very economical for shunting in small yards and departmental duties, the example seen here was purchased in 1929 and would be withdrawn in 1954 numbered 68146.

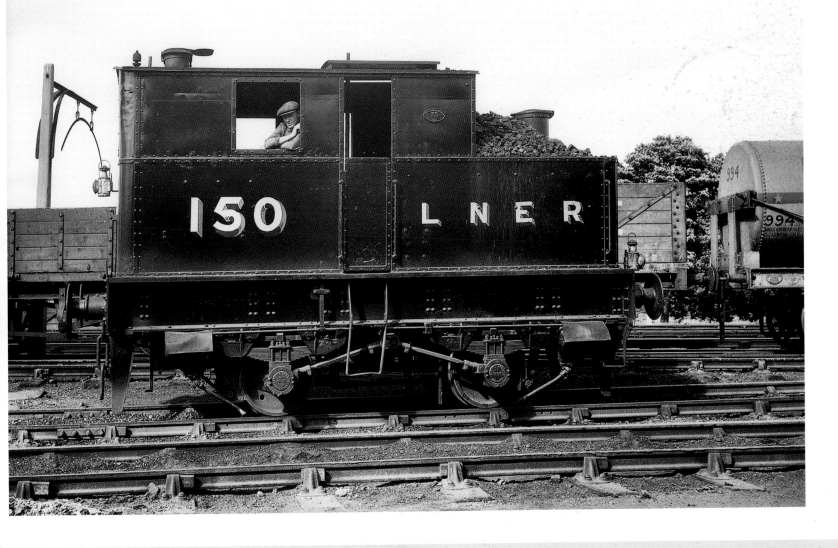

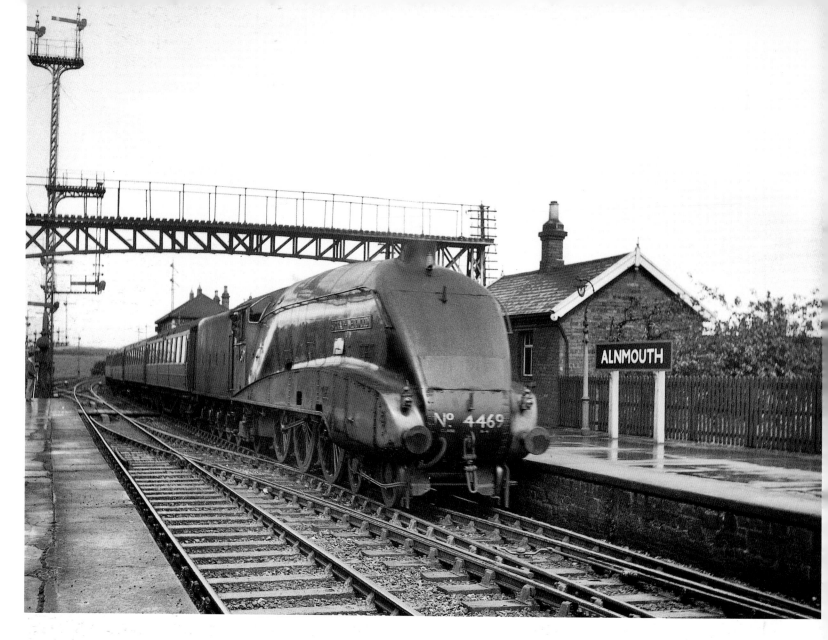

(Above and opposite) Friday 11 August 1939 The rain has stopped just in time for our photographer to capture two express passenger trains passing Alnmouth station. *Above:* LNER Class A4 4-6-2 No. 4469 *Sir Ralph Wedgewood* is seen working an 'up' train. Entering service in March 1938 from Doncaster Works, she originally carried the name *Gadwall* until March 1939, when she was renamed after the Chief Officer of the LNER. On the night of 28/29 April 1942, this locomotive was severely damaged during a German bombing raid on York and was subsequently scrapped.

Opposite: This spectacular shot was taken from the steps of the signal box at Alnmouth and shows LNER Class A4 4-6-2 No. 4490 *Empire of India* at speed at the head of the 'up' 'Flying Scotsman'. A product of Doncaster Works and entering service in June 1937, she would receive her name at a ceremony at King's Cross station on 28 June 1937. Being allocated to Haymarket shed in Edinburgh for the bulk of her working life, she was transferred to Ferryhill in Aberdeen in June 1962 and withdrawn while allocated there in May 1964.

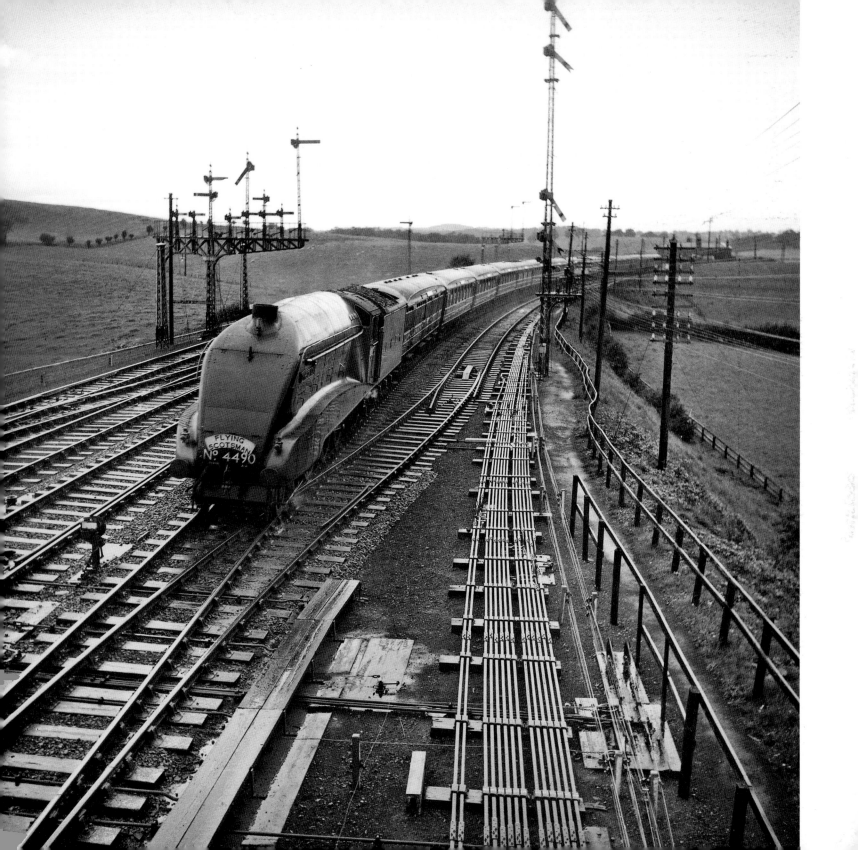

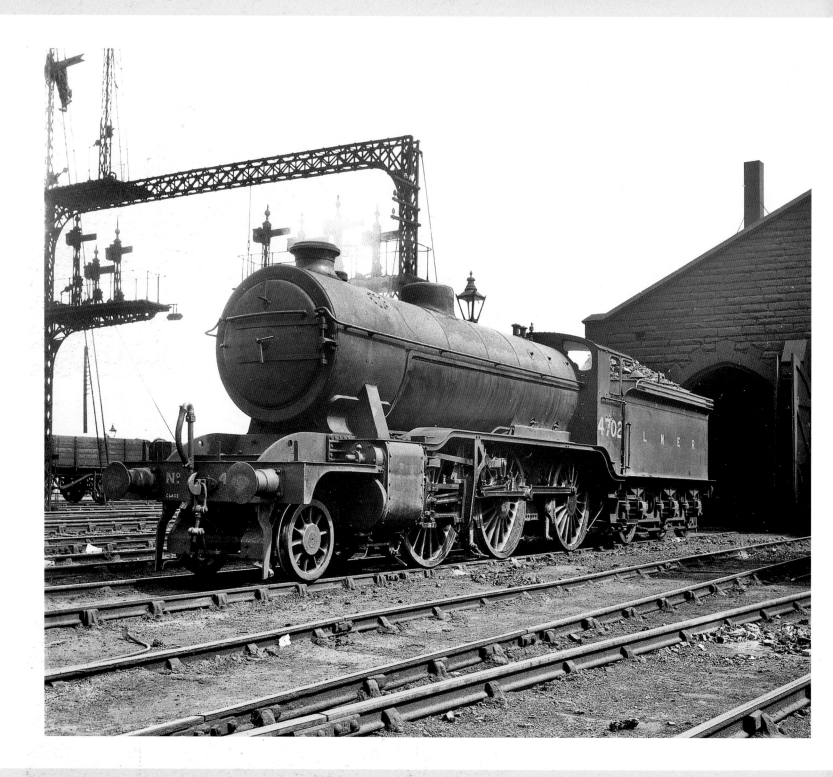

(Opposite) Friday 11 August 1939 Ex-GNR Class H3 (LNER Class K2) 2-6-0 No. 4702 is seen standing outside Tweedmouth shed with an impressive array of signal gantries in the background. Constructed by Kitson & Co. in 1921, she would be allocated to Scottish sheds throughout her working life, initially based at Eastfield in Glasgow but being quickly transferred to St Margarets, Edinburgh. By the early 1950s, numbered 61792, she would be working on the Great North of Scotland (GNoS) section based at Keith shed. She would be withdrawn from service in 1960.

Monday 14 August 1939 Ex-MR Class 3 (LMS Class 3F) 0-6-0 No. 3192 is seen here at Hellifield. Destined to become a real veteran, she was constructed at Derby Works in 1888 and withdrawn after seventy-one years' service in 1959.

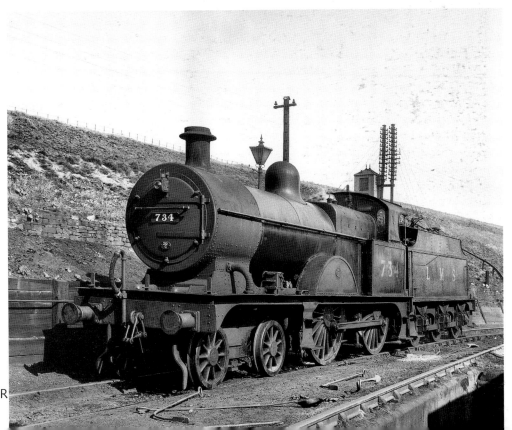

Monday 14 August 1939 Seen here standing in the yard at Hellifield shed is ex-MR Class 3 (LMS Class 3P) 4-4-0 No. 734. Constructed at Derby Works in 1919, she is bearing a 20G Hellifield shed code. She would be withdrawn in 1949. Note the fine selection of fire irons lying on the ground, clinker shovels, bent darts and prickers.

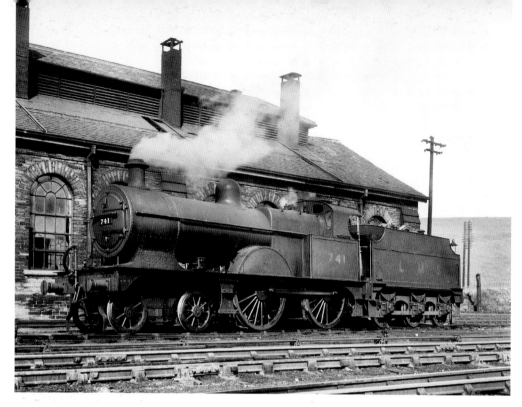

Monday 14 August 1939 The two locomotives seen here standing in Hellifield shed yard are examples of Samuel Johnson's express passenger Class 3 4-4-0, later classified 3P by the London, Midland & Scottish Railway (LMS). Both were constructed at Derby Works in 1919 during the Henry Fowler period as Chief Mechanical Engineer (CME). *Top:* No. 741, was destined to become No. 40741 and be withdrawn in 1951. *Bottom:* No. 743, was numbered 40743 with British Railways and withdrawn in 1952. Note that both locomotives are bearing 20G Hellifield shed codes; also note the differing style of tenders fitted.

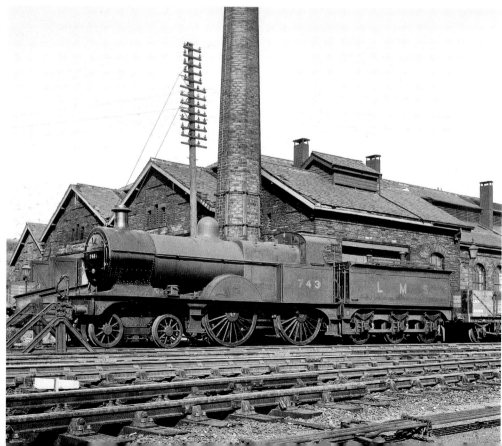

Monday 14 August 1939 Another Samuel Johnson-designed Class 3 4-4-0 is seen here waiting to depart from Hellifield station with an 'up' stopper. No. 747, bearing a 20G Hellifield shed code, was another Derby Works product entering service in 1919, which would be withdrawn numbered 40747 in 1951.

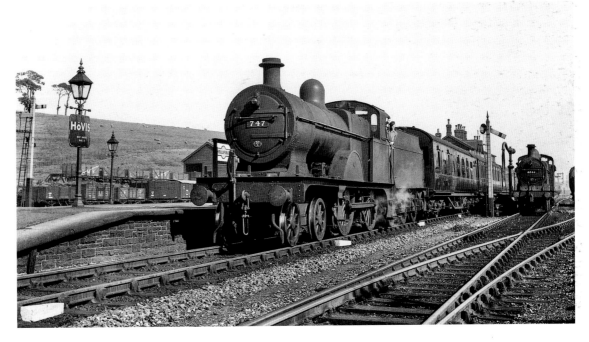

Monday 14 August 1939 Seen here at Skipton shed is ex-MR Class 3835 (LMS Class 4F) 0-6-0 No. 3893, which is running with a weatherboard-fitted tender. Designed by Henry Fowler, this locomotive was built at Derby Works in 1919 and would be withdrawn in 1965 numbered 43893 by British Railways.

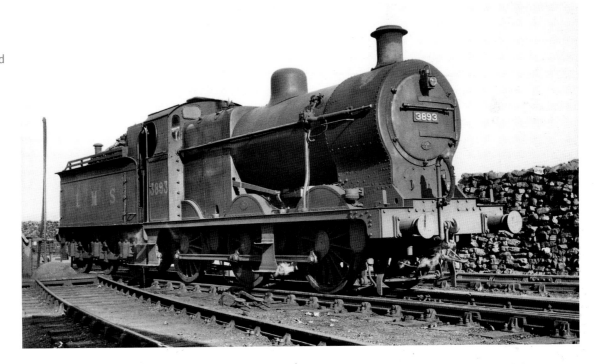

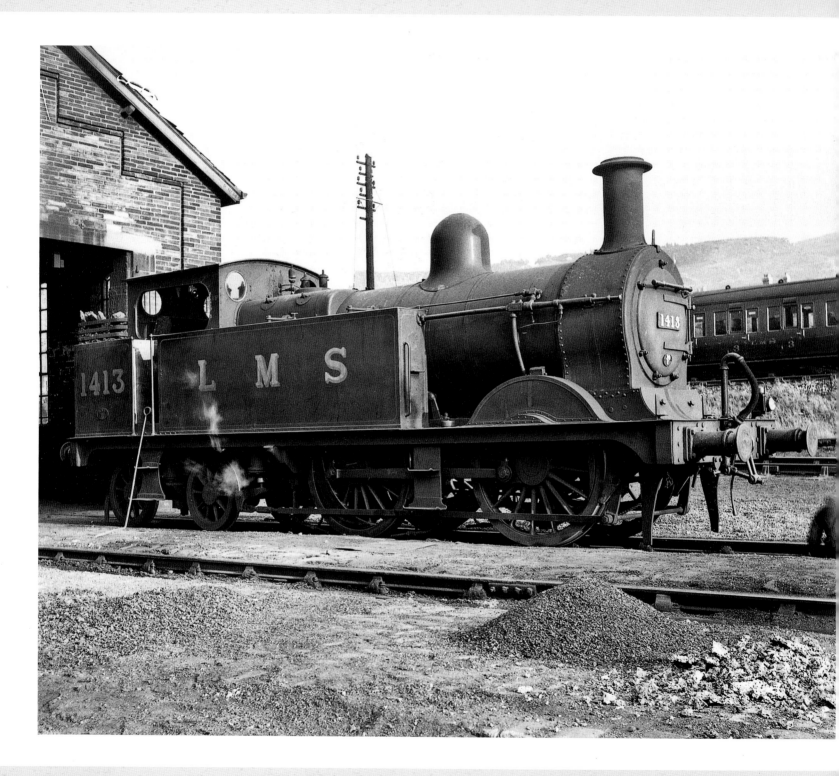

Monday 14 August 1939 For comparison, here are shown two types of 0-4-4 tank locomotives owned by the LMS, seen at Ilkley shed. *Opposite:* Ex-MR Class 2228 (LMS Class 1P) No. 1413, constructed during 1898 to a design by Samuel Johnson. She would give fifty years' service before withdrawal in 1948. *Right:* Two examples of only ten constructed Class 2 passenger tanks introduced in 1932, basically following MR practice. Again all built at Derby Works, they were initially fitted with stovepipe chimneys, as seen here, which would later be changed to a conventional style. They are *(top)* No. 6403, British Railways No. 41903, and *(bottom)* No. 6402, later British Railways No. 41902. Both would be withdrawn from service in 1959.

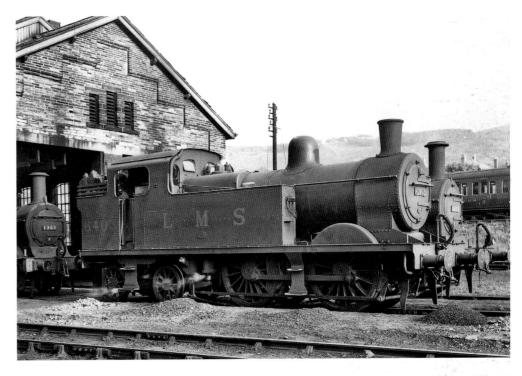

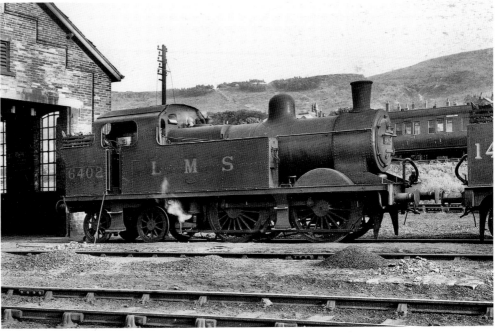

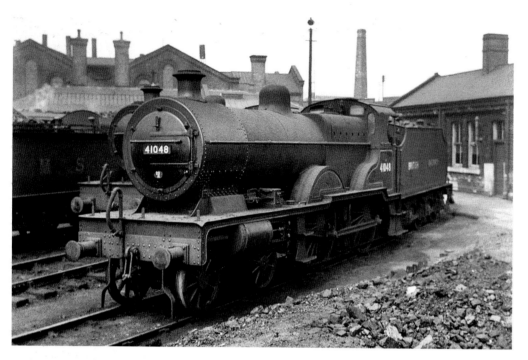

Sunday 15 May 1949 Parked in the yard at Holbeck shed in Leeds is ex-LMS Class 4P compound No. 41048. Henry Fowler continued the construction of these compound locomotives from 1924 on, incorporating a reduced driving wheel dimension of 6ft 9in instead of 7ft as used by the earlier MR locomotives. A total of 195 examples were constructed at Derby and Horwich Works, with both the Vulcan Foundry and the North British Locomotive Company (NBL) supplying a large number. The locomotive seen here was built at Derby Works in 1924 and would be withdrawn in 1957.

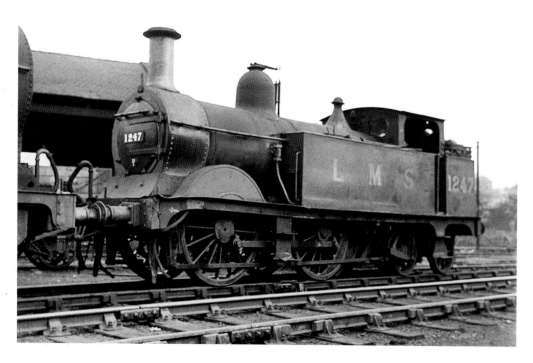

Sunday 15 May 1949 Seen here at Manningham shed and destined to be withdrawn within months of this photograph being taken, ex-MR Class 1252 (LMS Class 1P) 0-4-4 tank No. 1247 is showing signs of her long working life of seventy-three years. She is one of a class of thirty locomotives constructed by Neilson Reid & Co. during 1875 and 1876 to a design by Samuel Johnson.

Sunday 15 May 1949 Seen here waiting to depart from Bradford Exchange station is ex-GNR Class N1 (LNER Class N1) 0-6-2 tank No. 69478, proudly showing her new owner's identity. Designed by Henry Ivatt primarily to haul suburban passenger traffic, she was constructed at Doncaster Works in 1912 and was the first of her class to be fitted with a superheater in 1918. She would be withdrawn from service in 1956.

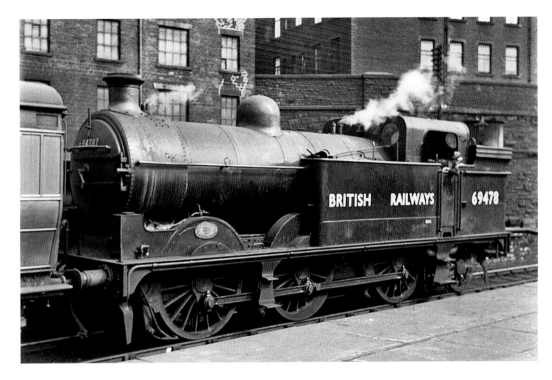

Sunday 27 May 1951 Introduced in 1901, the GCR Class 9J 0-6-0 goods locomotives designed by John Robinson appear to have acquired their 'pom-pom' nickname very quickly. A large number were constructed over a period of nine years by Gorton Works, Neilson Reid & Co., Beyer Peacock & Co., the Vulcan Foundry and the Yorkshire Engine Co. They were classified J11 by the LNER and all survived to enter service with British Railways. The example seen here at Mexborough shed, No. 64374, was from the Vulcan Foundry; she entered service in 1904 and would be withdrawn in 1955.

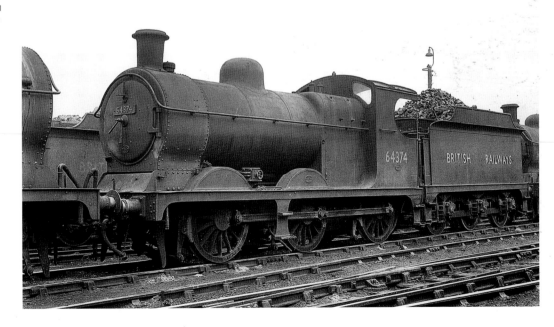

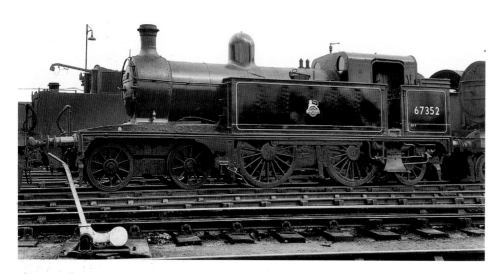

Sunday 27 May 1951 The two graceful-looking locomotives, seen here at Doncaster Works, are ex-GNR Class C2 (LNER Class C12) 4-4-2 tanks designed by Henry Ivatt and introduced in 1898. Constructed in batches at Doncaster Works, a total of sixty appeared between that date and 1907. Designed to handle suburban passenger traffic, they found work in the West Riding of Yorkshire and could cope with the heavy demands of King's Cross, London. *Top:* No. 67352, built in 1898, would serve for sixty years before withdrawal in 1958. *Bottom:* No. 67392 entered service in 1907 and would be withdrawn in 1949.

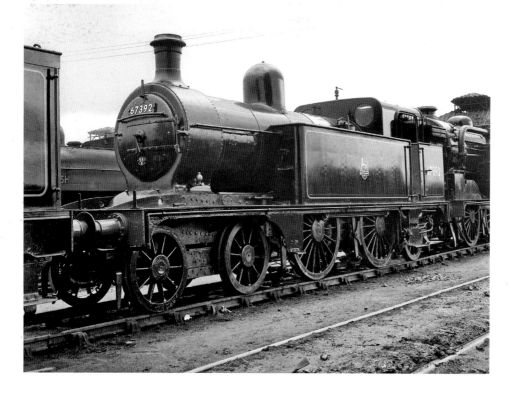

Sunday 27 May 1951 The two locomotives seen here, again at Doncaster Works, are representatives of the class that finally replaced the Class C12 seen opposite. Nigel Gresley-designed Class N2 0-6-2 tanks for the GNR were powerful locomotives and were introduced in 1920, seeing service in Scotland, Yorkshire and the London area. *Top:* No. 69567, built at Doncaster in 1925, would be withdrawn in 1959. *Bottom:* No. 69578 was a product of Hawthorn Leslie & Co., Newcastle, in 1929 and would also be withdrawn in 1959.

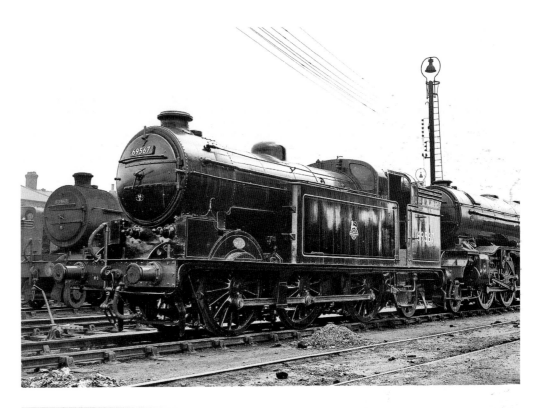

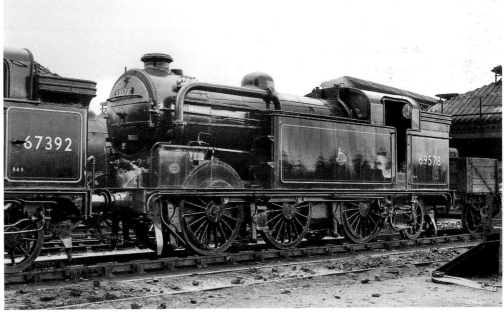

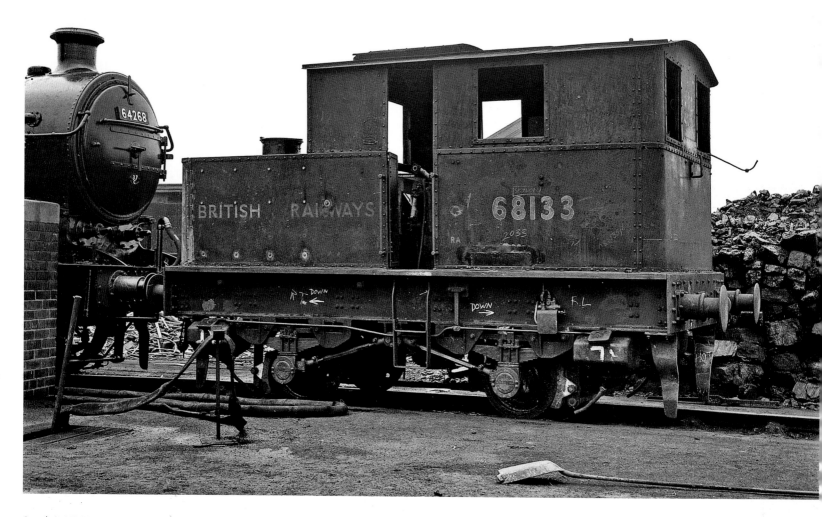

Sunday 27 May 1951 Awaiting attention in Doncaster Works yard is ex-LNER Class Y1 Sentinel locomotive No. 68133. Purchased by the LNER in 1926, she spent her entire working life at Peterborough Engineers yard and would be withdrawn in 1955.

(Opposite) Sunday 27 May 1951 Another locomotive seen here in Doncaster Works yard awaiting attention is something of a rarity. With only ten examples constructed, the last design of Henry Ivatt before his retirement as Locomotive Superintendent of the GNR was for a superheated goods traffic locomotive. Ex-GNR Class J21 (LNER Class J2) 0-6-0 No. E5022 was a product of the same works in 1912 and would be withdrawn in 1953 numbered 65022.

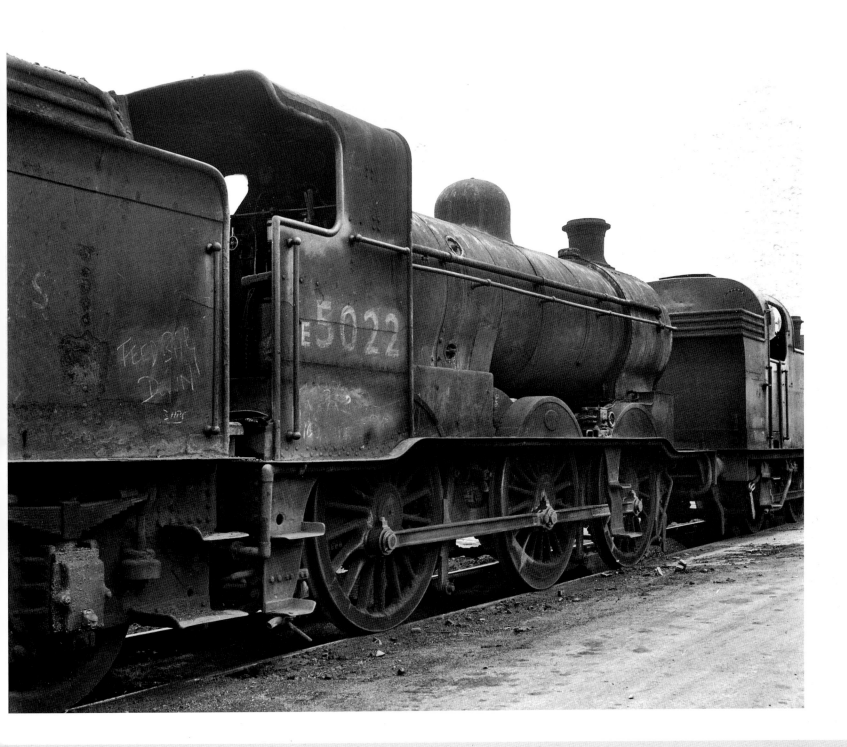

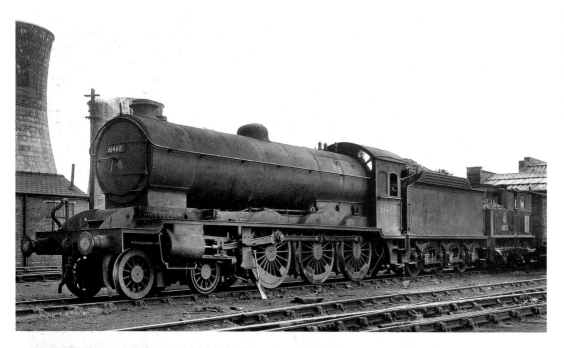

Saturday 12 July 1952 Seen here in the yard at Darlington shed is ex-NER Class S3 (LNER Class B16) 4-6-0 No. 61460. A post-grouping-built example of this Vincent Raven-designed class, she entered service in 1923 from Darlington Works and would be withdrawn in 1961.

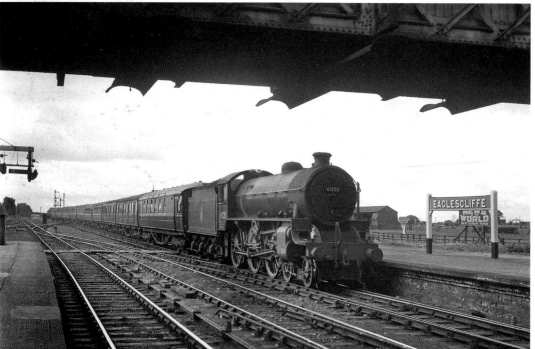

Saturday 12 July 1952 Approaching the stop at Eaglescliffe station at the head of the 8.55 a.m. Filey Camp to Newcastle train is ex-LNER Class B1 4-6-0 No. 61128. She was a member of a class of over 400 examples designed by Edward Thompson, construction of which took place over a period of ten years between 1942 and 1952. Manufactured at both Darlington and Gorton Works, the vast majority – 290 examples – were constructed by the NBL in Glasgow, with the Vulcan Foundry contributing fifty examples. No. 61128 was an NBL-built locomotive of 1947 that would be withdrawn in 1962.

(Opposite) Saturday 12 July 1952 Another veteran locomotive is seen here at Stockton shed. Ex-NER Class 290 (LNER Class J77) 0-6-0 tank No. 68420 was originally constructed in 1878 at Gateshead Works as a 0-4-4 well tank. Rebuilt in 1921 at Darlington Works as a 0-6-0 tank, she would serve for seventy-seven years, before withdrawal in 1955.

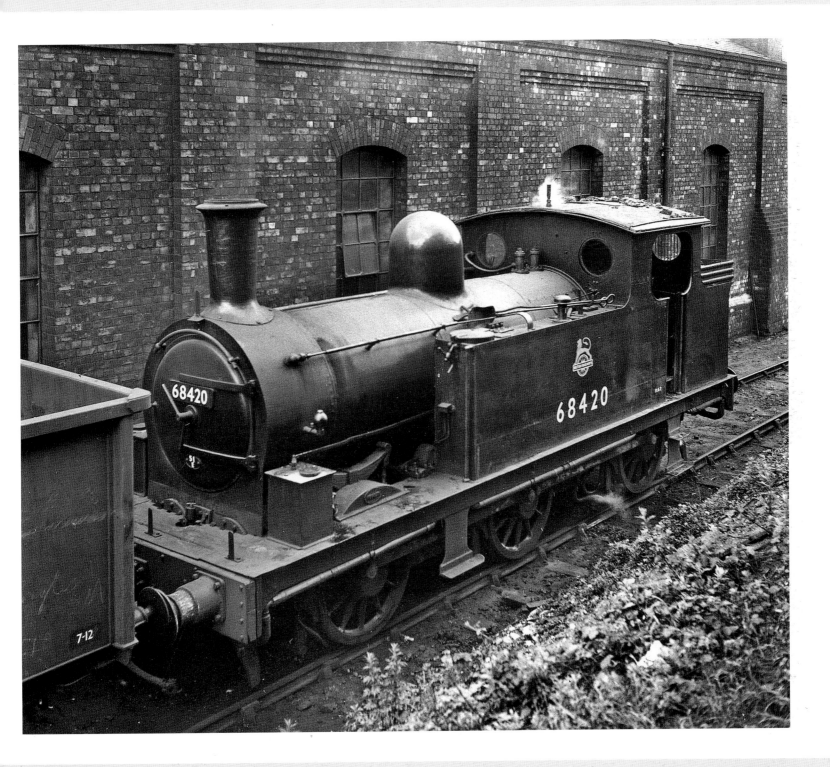

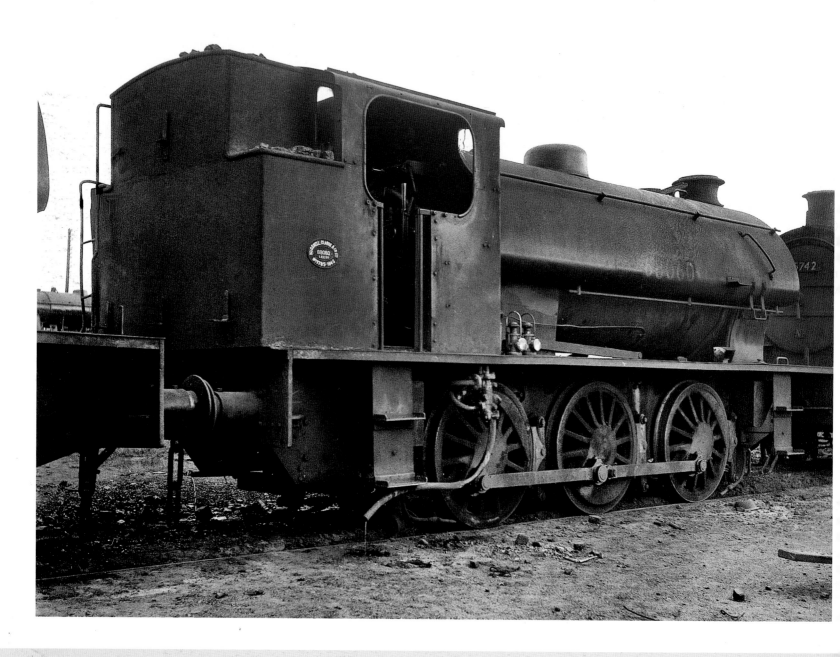

(Opposite) Saturday 12 July 1952 The powerful bulk of LNER Class J94 0-6-0 saddle tank No. 68060 is clearly evident here at Newport shed. Designed by Robert Riddles for the Ministry of Supply and constructed by Hudswell Clarke in 1945, she was one of seventy-five examples of the class to be purchased by the LNER from the War Department (WD) during 1946 and 1947. Numbered 71467 by the WD, she would become No. 8060 with the LNER and be fitted with an extended bunker, as seen here soon after its purchase by them. She would be withdrawn from service in 1965.

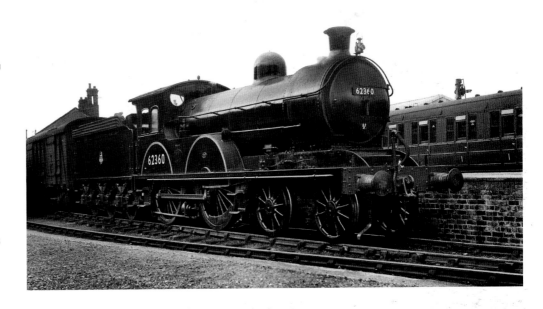

Saturday 12 July 1952 Looking in good, clean condition, and seen here at West Hartlepool station, is one of only three examples of the ex-NER Class R (LNER Class D20) 4-4-0 to be rebuilt and classified D20/2. No. 62360 was a product of Gateshead Works in 1900, fitted with a superheating boiler in 1919 and rebuilt in the form seen here in 1942. She would be withdrawn in 1956.

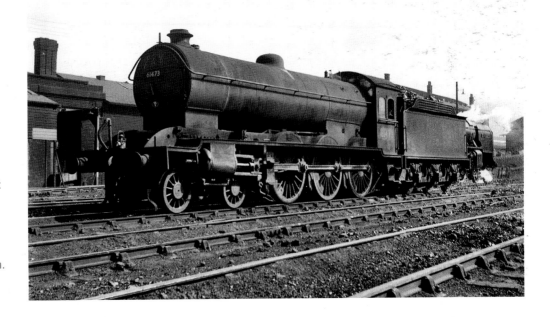

Sunday 13 July 1952 The first ten examples of Vincent Raven's Class S3 4-6-0 for the NER appeared from Darlington Works during 1919 and 1920. Seen here at Gateshead shed is a 1919-constructed example, No. 61473. Classified B16 by the LNER, a total of thirty-eighty examples would be built, all at Darlington. The locomotive shown here would be withdrawn in 1961.

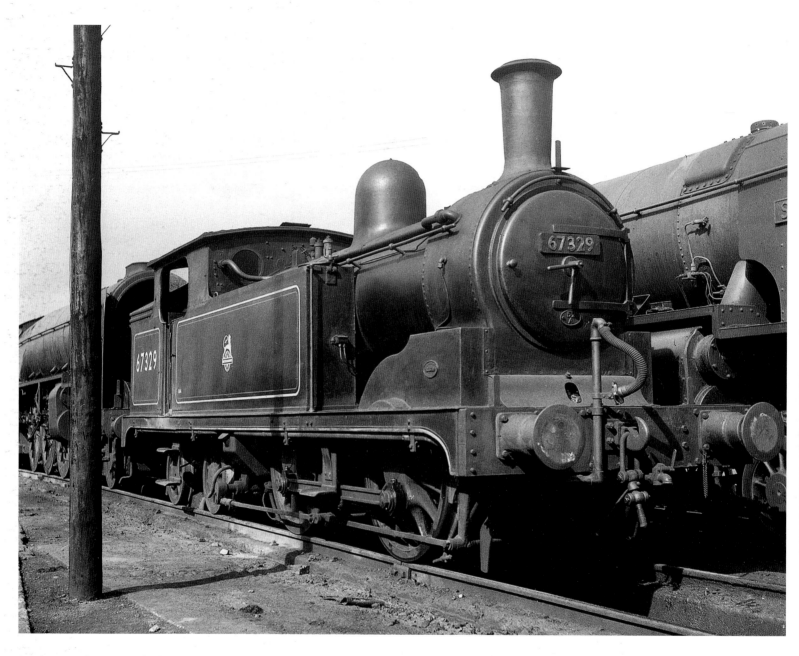

Sunday 13 July 1952 Parked in the yard at Gateshead shed is ex-NER Class O (LNER Class G5) 0-4-4 tank No. 67329. Built at Darlington Works in 1901, she would manage fifty-seven years' service before withdrawal in 1958.

(Opposite) Sunday 13 July 1952 Another LNER Class G5 0-4-4 tank, seen at Gateshead, is No. 67263, looking to be in ex-works condition. Constructed at Darlington Works in 1896, she managed sixty-two years' service, also to be withdrawn in 1958.

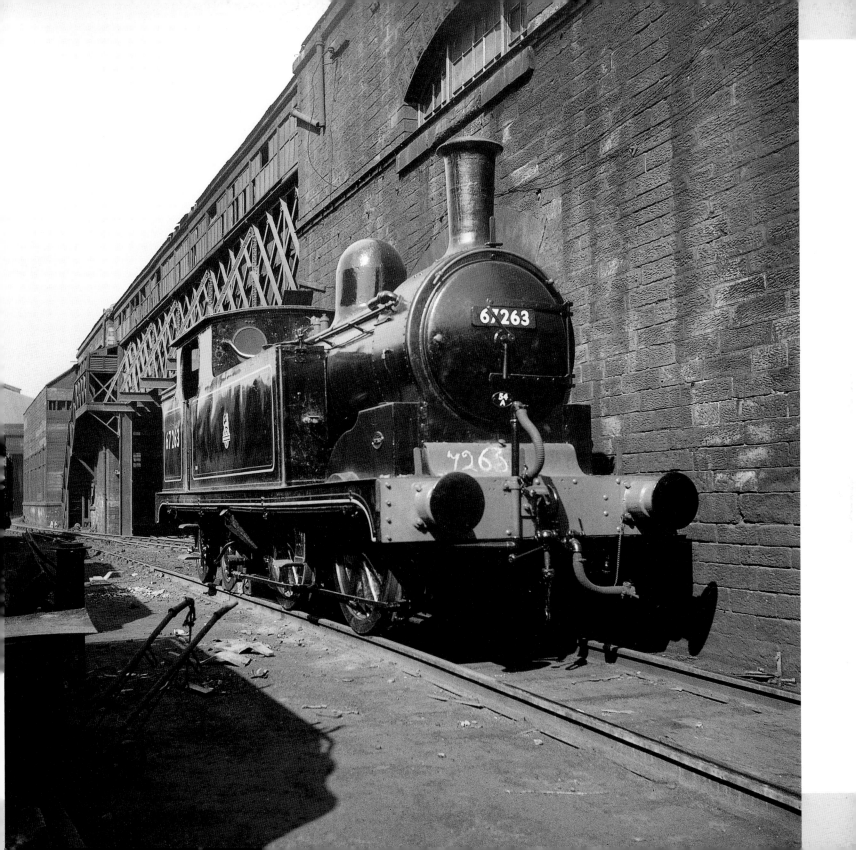

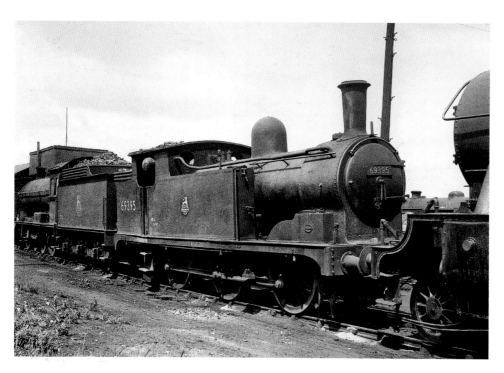

Sunday 13 July 1952 The first ten examples of the NER Class B 0-6-2 tank locomotive, designed by Thomas Worsdell and introduced in 1886, were of simple two-cylinder construction, but the fifty examples built between 1888 and 1890 were of a two-cylinder compound configuration. All of the compound locomotives were later converted to the two-cylinder simple form and, after the grouping, were classified N8 by the LNER. Seen here at Blaydon shed is No. 69395, constructed at Darlington Works in 1890 as a compound. She would be rebuilt in 1907, fitted with a superheating boiler in 1921 and withdrawn from service in 1952 having given sixty-two years' service.

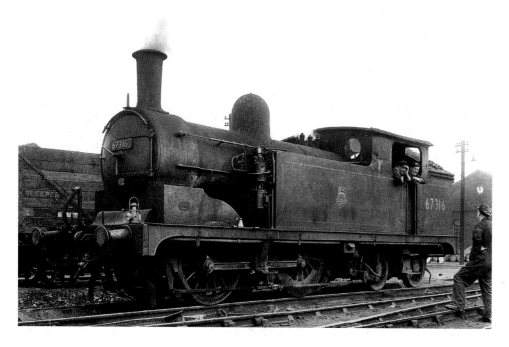

Sunday 13 July 1952. The crew on ex-NER Class O (LNER Class G5) 0-4-4 tank No. 67316, take some time to converse with a colleague whilst standing in the yard at Blaydon shed. Built in 1900 at Darlington Works, this locomotive would be withdrawn during 1955.

Sunday 13 July 1952 Parked in the yard at Heaton shed is ex-NER Class S3 (LNER Class B16) 4-6-0 No. 61413. Constructed in 1920 at Darlington Works, she would be withdrawn in 1961.

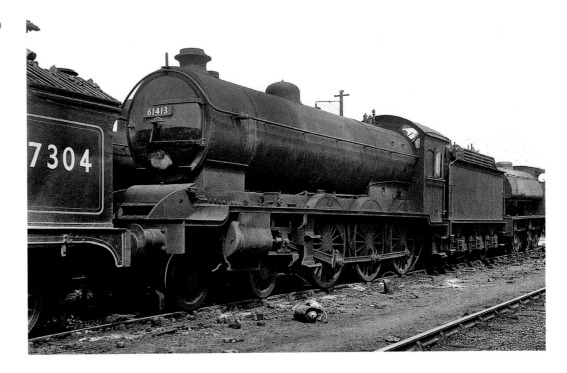

Sunday 13 July 1952 Undoubtedly two of Nigel Gresley's most successful designs of passenger tank locomotives were his Class V1 and V3 2-6-2s, introduced in 1930. A total of ninety-two examples were constructed over a period of ten years, all at Doncaster Works. Seen here standing in Heaton shed yard is Class V1 No. 67651, which would be rebuilt as a Class V3 locomotive in 1956. Allocated to Heaton from new in 1936, she would spend the bulk of her working life based there, being withdrawn from service at Gateshead shed in 1964.

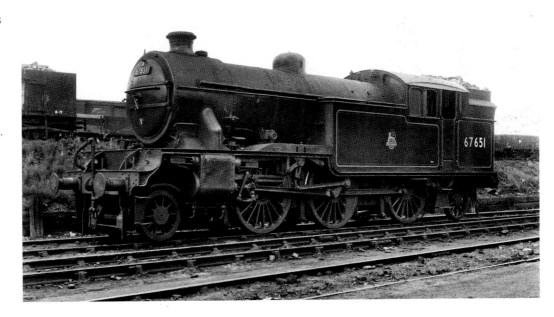

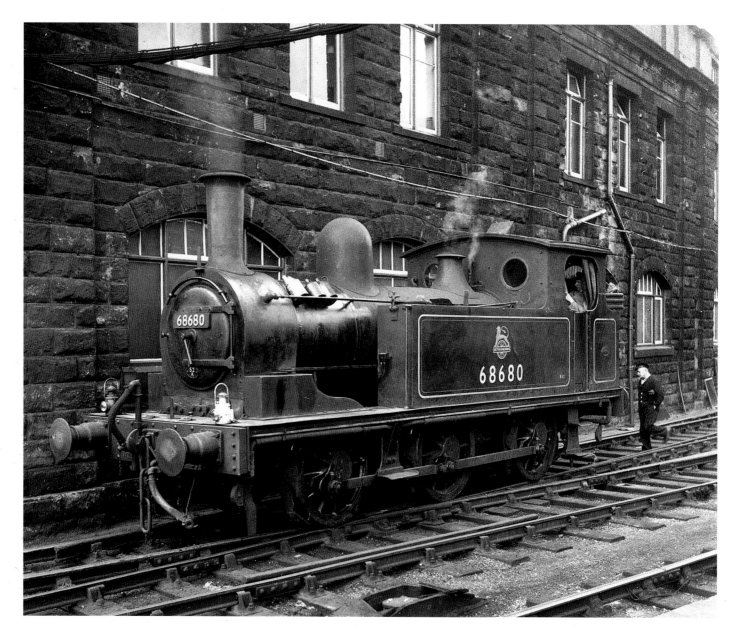

Sunday 13 July 1952 Pausing between duties at Newcastle Central station is ex-NER Class E1 (LNER Class J72) 0-6-0 tank No. 68680. One of the crew is relaxing, reading a newspaper, and the oil bottles are lined up on the handrail keeping warm. This long-time Newcastle station pilot had only recently seen its livery change from green to black. Constructed at Darlington Works in 1899, she would serve for sixty-two years before withdrawal in 1961.

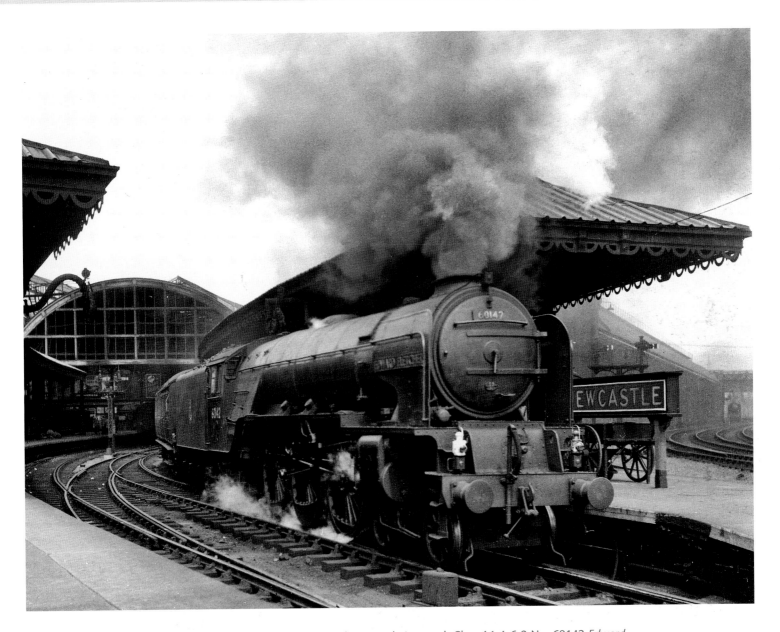

Sunday 13 July 1952 With the steam sanding gear being used, Class A1 4-6-2 No. 60142 *Edward Fletcher* is seen departing from Newcastle station at the head of an express bound for Leeds. Constructed at Darlington Works in 1949 and allocated to Gateshead shed for the bulk of her working life, she would be withdrawn after only sixteen years' service in 1965. None of this class of forty-nine examples passed into the preservation scene, but the A1 Steam Locomotive Trust built and operate the fiftieth member of the class, No. 60163 *Tornado*, which came into service in 2008.

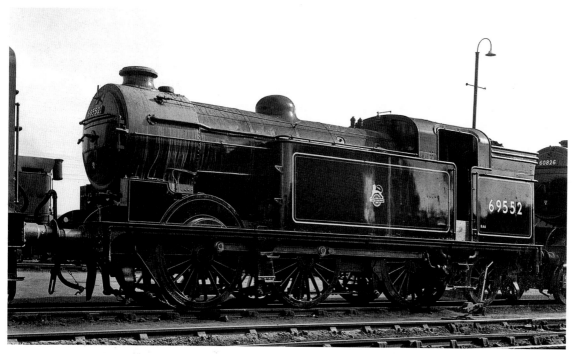

Sunday 15 March 1953 Standing ex-works in Doncaster Works yard is ex-GNR Class N2 (LNER Class N2) 0-6-2 tank No. 69552. An example of a class of 107 locomotives built over a period of nine years between 1920 and 1929, she was from a batch of twelve constructed by Beyer Peacock & Co. in 1925. Other examples were the product of Doncaster Works, the NBL in Glasgow, Hawthorn Leslie & Co. and the Yorkshire Engine Co. Formerly numbered 2585 with the LNER and initially allocated to the Scottish area, by the time of this photograph she was allocated to Stratford (30A), whose shed code she is bearing. She would be withdrawn in 1960.

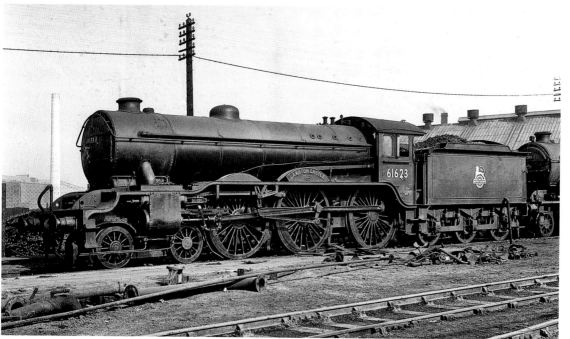

Sunday 15 March 1953 Primarily designed to handle the heavy express workings on the Great Eastern section of the LNER, the three-cylinder Class B17 4-6-0s introduced in 1928 initially bore names of great country houses associated with that area, with later additions to the class bearing the names of football clubs. The bulk of the class of seventy-three examples were allocated to sheds within the former GER area but were also used on Marylebone to Leicester and Manchester workings. Seen here in the yard at Doncaster is No. 61623 *Lambton Castle*, a Darlington Works-constructed example from 1931 that would be withdrawn from service in 1959.

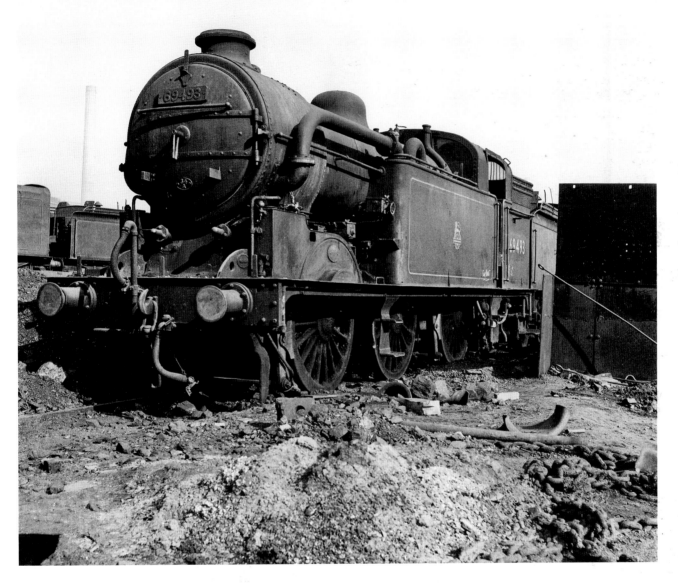

Sunday 15 March 1953 Seen here in a filthy state in Doncaster Works yard is ex-GNR Class N2 (LNER Class N2) 0-6-2 tank No. 69493. Constructed at the same works in 1921, fitted with condensing gear and allocated to King's Cross shed, she appears to have been based there for the greater part of her working life. She would be withdrawn in 1958.

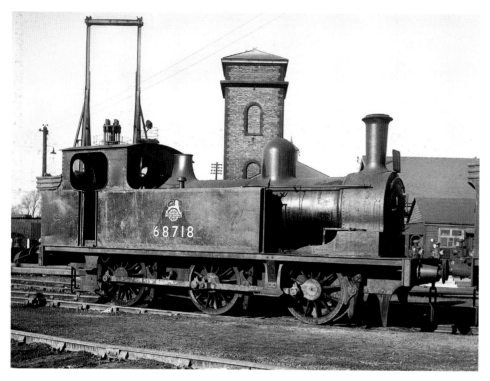

Sunday 15 March 1953 Photographed at Alexandra Dock shed, Hull, are two ex-NER Class E1 (LNER Class J72) 0-6-0 tanks. *Top:* No. 68718 was built at Darlington Works in 1920 and withdrawn from service in 1958. *Bottom:* No. 68747 was constructed at Doncaster Works in 1925 and withdrawn in 1961.

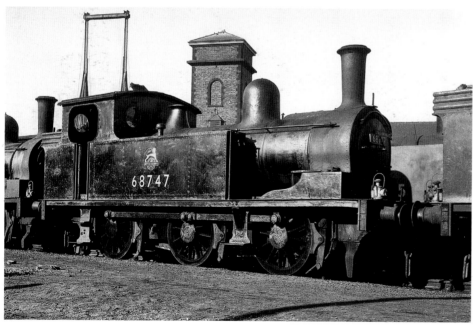

Sunday 15 March 1953 A further pair of LNER Class J72s seen at Alexandra Dock shed. *Top:* No. 68752 was built at Doncaster Works in 1925 and withdrawn in 1960. *Bottom:* A post-Nationalisation example of the class, No. 69003 was constructed at Darlington Works in 1949 and would only see fourteen years' service before withdrawal in 1963.

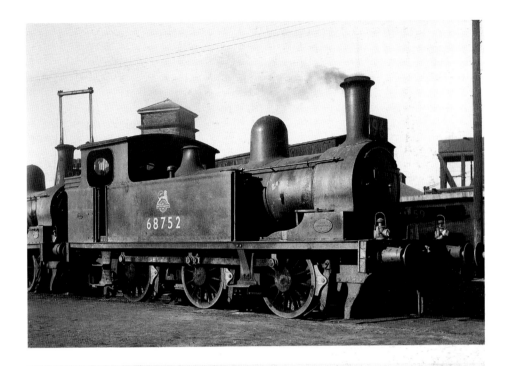

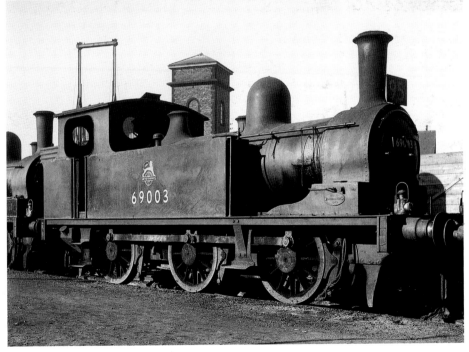

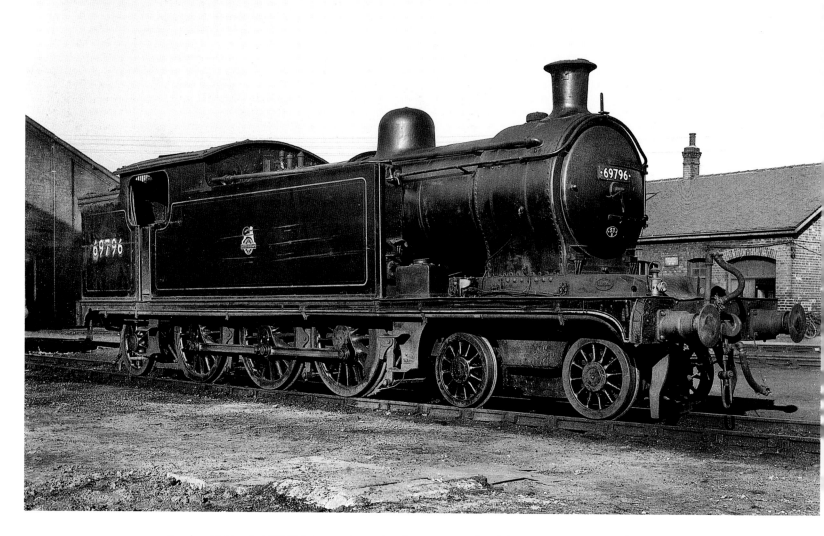

Sunday 15 March 1953 This impressive and well-proportioned tank locomotive was the last of her class, LNER Class A6, surviving two years longer than any of her nine classmates. Designed by Wilson Worsdell with a 4-6-0 wheel arrangement as the first class of six-coupled passenger tank locomotives for the NER, Class W was introduced in 1907 with only ten examples being constructed, all at Gateshead Works. Rebuilt as 4-6-2 tanks with larger bunkers between 1914 and 1917, seven of the class received superheating boilers between 1937 and 1944, which improved their performance. Seen here at Hull Botanic Gardens shed is No. 69796, bearing the correct 53B shed code. Constructed in 1908, she would serve for forty-five years before withdrawal in March 1953.

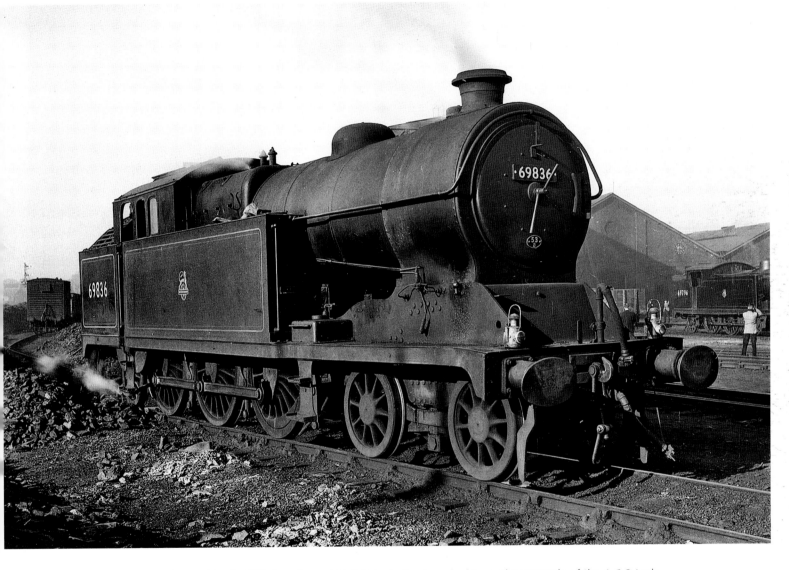

Sunday 15 March 1953 Seen here at Hull Botanic Gardens shed is another example of the 4-6-2 tank configuration, this time with the impressive bulk of ex-GCR Class 9N (LNER Class A5) No. 69836. Designed by John Robinson to replace the ageing 'Atlantic' tanks working the suburban traffic from Marylebone, a total of forty-four examples with superheating boilers were constructed and introduced in 1911. In later years members of the class would find work in Yorkshire and East Anglia. The example seen here was a product of Hawthorn Leslie & Co. in 1925 and would be withdrawn in 1958.

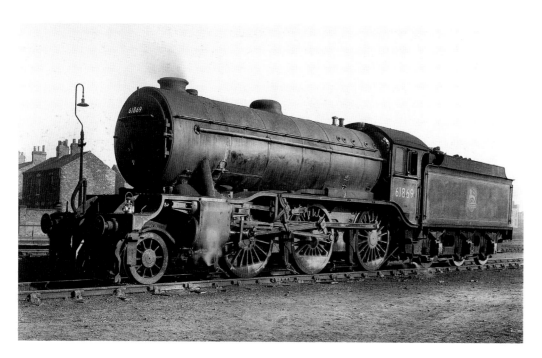

Sunday 15 March 1953 Ex-LNER Class K3 2-6-0 No. 61869 awaits her next duty while parked in the yard at Hull Botanic Gardens shed. A Darlington-built example of the class from 1925, she would spend much of her career based at March shed. She would be withdrawn in 1962.

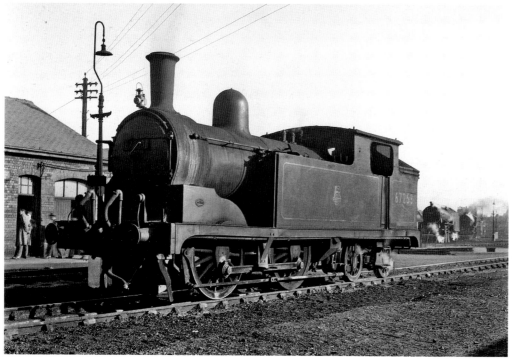

Sunday 15 March 1953 Ex-NER Class O (LNER Class G5) 0-4-4 tank No. 67253 was constructed at Darlington Works in 1895 and was fitted with push-pull gear in 1939. Seen here at Hull Botanic Gardens shed, she would be withdrawn from service in 1958.

Sunday 15 March 1953 The graceful lines of Henry Ivatt's design of suburban passenger tank are clearly seen here in ex-GNR Class C2 (LNER Class C12) 4-4-2 tank No. 67395. Built at Doncaster Works in 1907 as one of the last of the class of sixty examples, she spent most of her life based at Hull Botanic Gardens, where this photograph was taken. She would be withdrawn in 1957 having given fifty years' service.

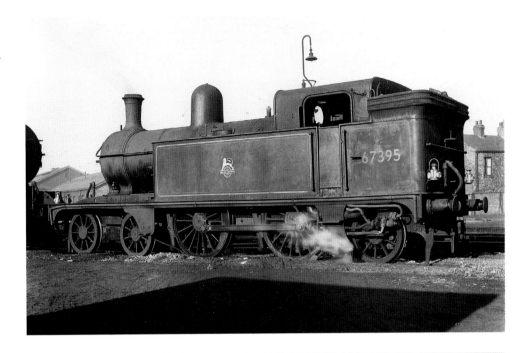

Sunday 15 March 1953 Edward Thompson's most successful design for the LNER was undoubtedly his Class B1 4-6-0 general-purpose locomotive, introduced in 1942, whose last member appeared in 1952. A total of 410 examples were built, with the largest number coming from the NBL in Glasgow. Other manufacturers included Darlington and Gorton Works and the Vulcan Foundry. Seen here at Hull Botanic Gardens is No. 61074, a product of the NBL during 1946 that would be withdrawn in 1963.

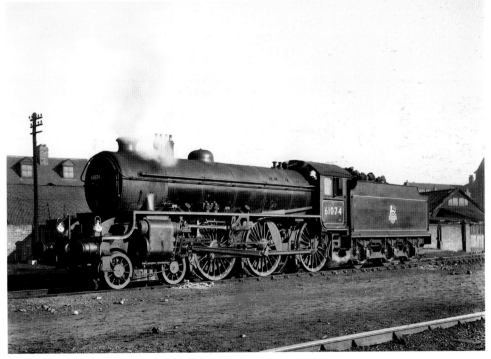

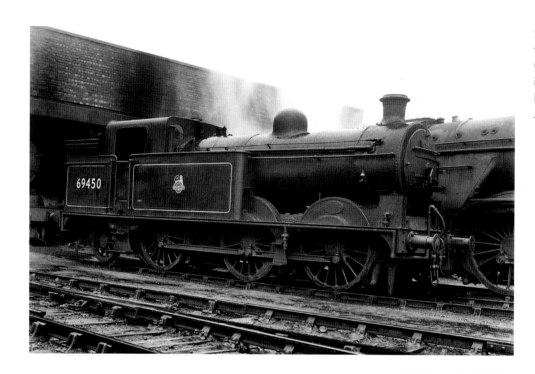

Sunday 12 April 1953 Sister locomotives are seen here with Henry Ivatt-designed ex-GNR Class N1 (LNER Class N1) 0-6-2 tanks, both constructed at Doncaster in 1910. *Top:* No. 69450 at Copley Hill shed; she would be withdrawn in 1959. *Bottom:* No. 69449 at Bowling Junction near Bradford; she would be withdrawn in 1955.

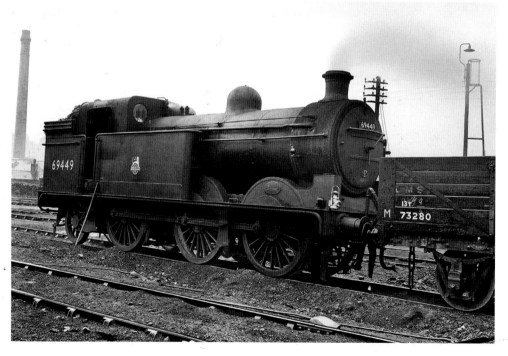

Sunday 12 April 1953 A pair of William Barton Wright-designed Class 25 (LMS Class 2F) 0-6-0s for the L&YR are seen here both at Wakefield shed. *Top:* No. 52053, bearing the early British Railways identity on its tender, was constructed by Beyer Peacock & Co. in 1887 and would be withdrawn from service in 1955. *Bottom:* No. 52044, again a product of Beyer Peacock & Co. in 1887, would be numbered 957 by the L&YR and bought for preservation on withdrawal in 1959. She is currently awaiting an overhaul at the Keighley & Worth Valley Railway.

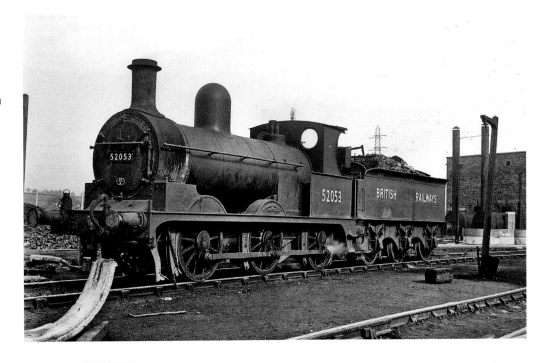

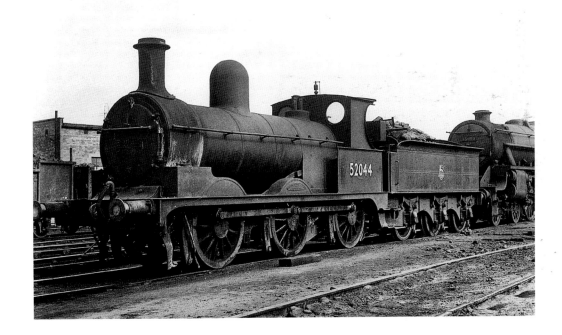

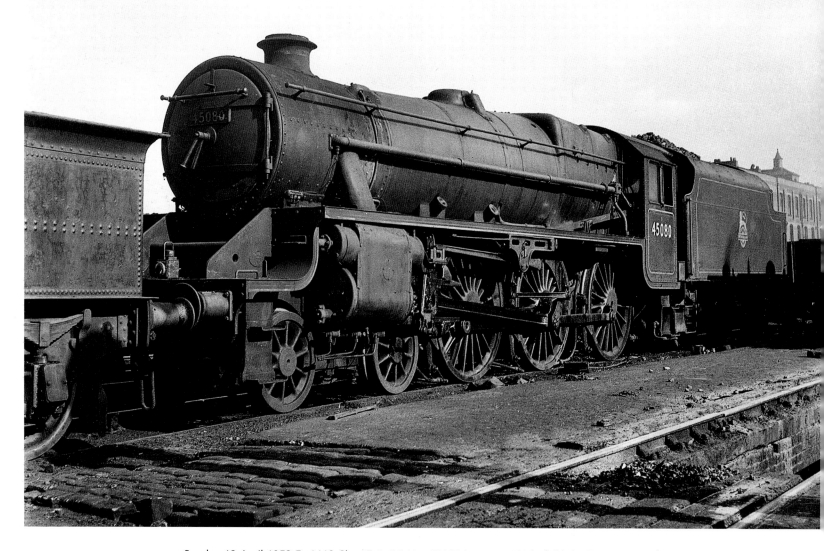

Sunday 12 April 1953 Ex-LMS Class 5 4-6-0 No. 45080 is seen at Wakefield shed. Constructed by the Vulcan Foundry in 1935, she would be withdrawn in 1967. This was an outstandingly successful design from William Stanier, introduced in 1934; a total of 842 examples were constructed, with the last appearing during British Railways days in 1951.

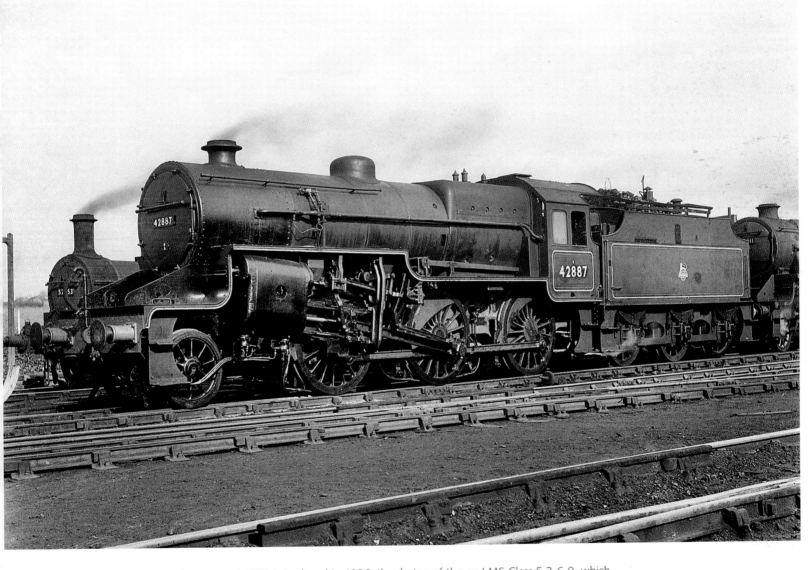

Sunday 12 April 1953 Introduced in 1926, the design of the ex-LMS Class 5 2-6-0, which became known to railwaymen as 'Crabs', was attributed to George Hughes, formerly of the L&YR. A total of 245 examples of this versatile class of locomotive were produced over a period of six years by both Crewe and Gorton Works. The example seen here at Wakefield shed is No. 42887, a 1930 product of Crewe Works that would be withdrawn in 1962.

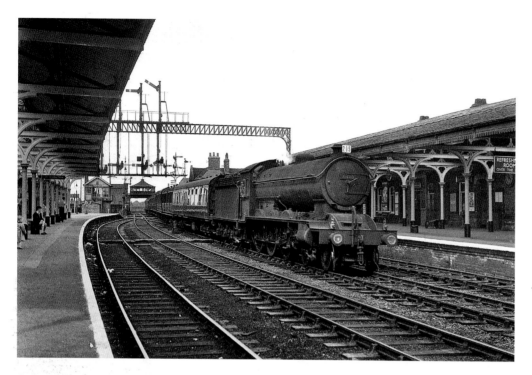

Saturday 1 August 1953 With the operating cab of Selby swing bridge seen in the background, ex-NER Class S3 (LNER Class B16) 4-6-0 No. 61440 moves slowly through the centre roads at Selby station at the head of an 'up' express. Constructed at Darlington Works in 1923, she would be withdrawn in 1960. Note the use of both upper and lower quadrant signals.

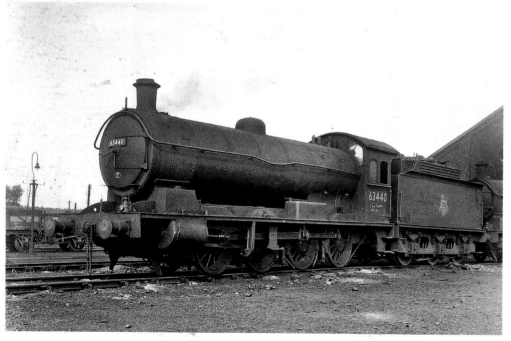

Saturday 1 August 1953 Bearing a 50C shed code, ex-NER Class T2 (LNER Class Q6) 0-8-0 No. 63440 is sitting in the yard at her home shed, Selby. A product of Armstrong Whitworth in 1920, she would be withdrawn in 1966.

(Opposite) Saturday 1 August 1953 An example of the highly versatile and successful ex-LNER Class V2 2-6-2 design of mixed-traffic locomotive by Nigel Gresley is seen here at Doncaster. In ex-works condition, No. 60875 is bearing a 36A Doncaster shed code. A total of 184 examples of this three-cylinder locomotive were constructed at both Doncaster and Darlington Works between 1936 and 1944. The example seen here was from Doncaster, entering service in 1939 and withdrawn in 1962.

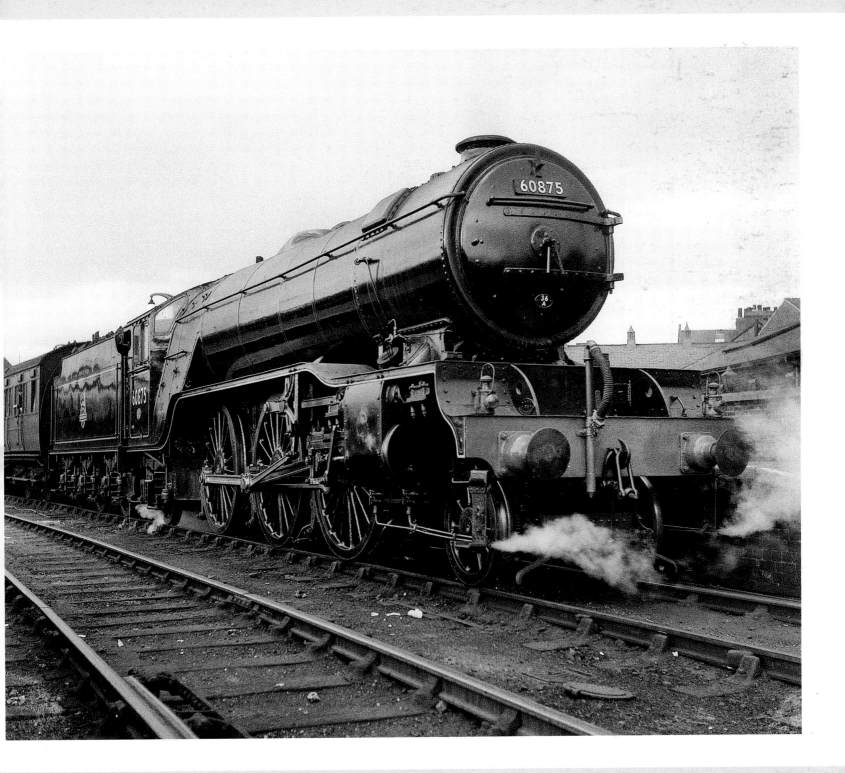

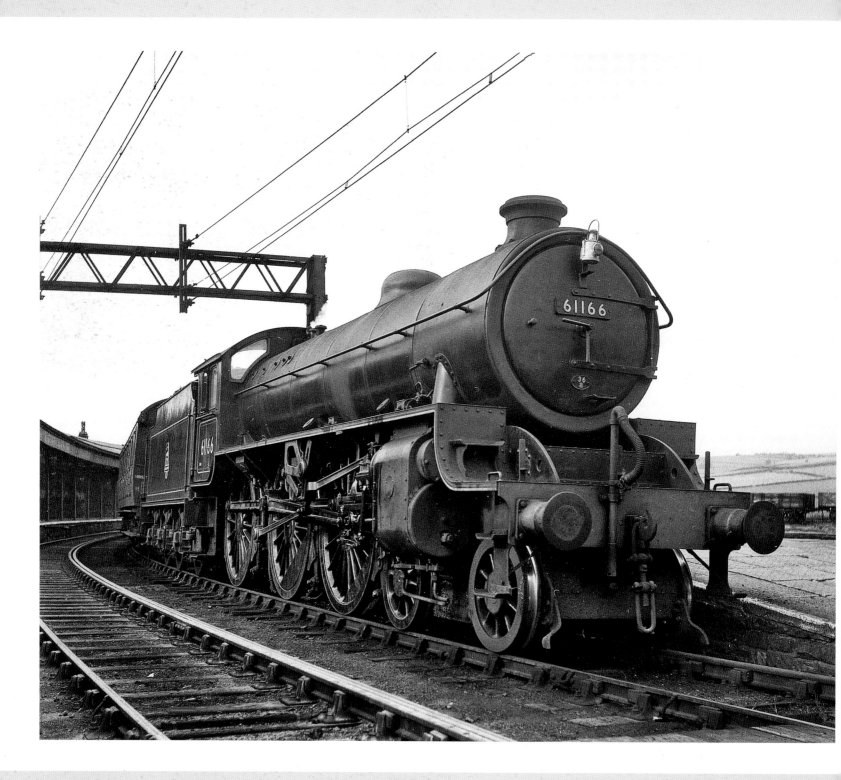

(Opposite) Saturday 5 September 1953 Seen here at Penistone station at the head of the 4.53 p.m. 'stopper' to Mexborough is ex-LNER Class B1 4-6-0 No. 61166. Constructed by the Vulcan Foundry in 1947, she would be withdrawn in 1962.

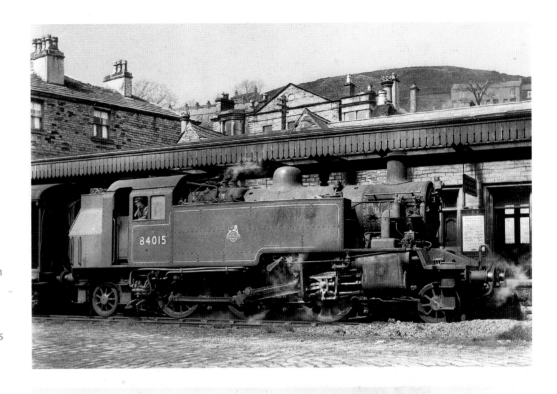

Saturday 30 April 1955 British Railways Standard Class 2 2-6-2 tank No. 84015 is seen here at Delph station, having arrived with the 11.33 a.m. train from Oldham during the last day of passenger operations on the branch. Known locally as the 'Delph Donkey', the branch was opened in 1851 to serve the mill town. The locomotive was a product of Crewe Works in 1953 that would be withdrawn after only twelve years' service, in 1965.

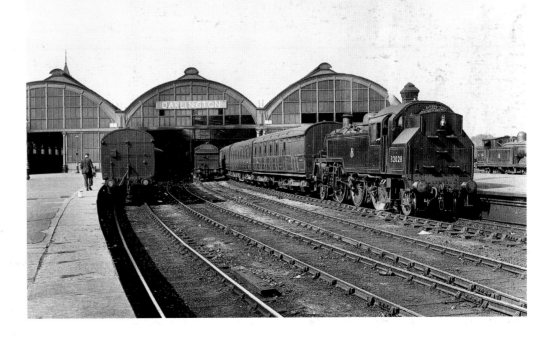

Saturday 30 July 1955 With the graceful triple spans of Darlington station roof in the background, British Railways Standard Class 3 2-6-2 tank No. 82028 is waiting to depart with the 4.30 p.m. 'stopper' to Saltburn. Constructed at Swindon Works in 1954, she would only manage twelve years' service before withdrawal in 1966.

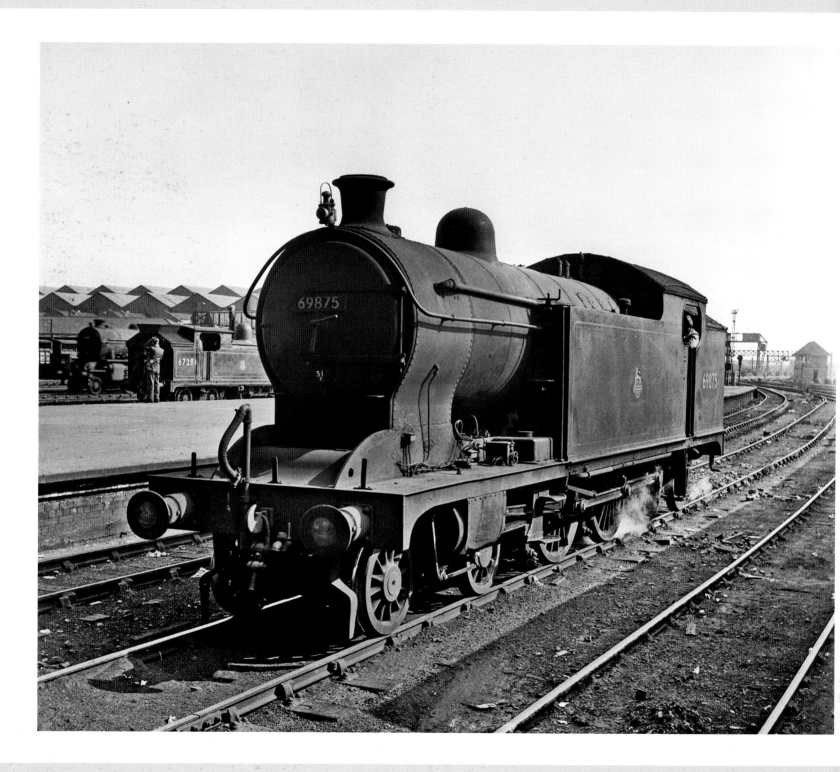

(Opposite) **Saturday 30 July 1955** At Darlington station, waiting for its next duty, is ex-LNER Class A8 4-6-2 tank No. 69875. Originally constructed as a three-cylinder Class D (LNER Class H1) 4-4-4 tank locomotive, she was rebuilt by the LNER in 1938 as a 4-6-2 tank and designated Class A8. She would be withdrawn in 1960.

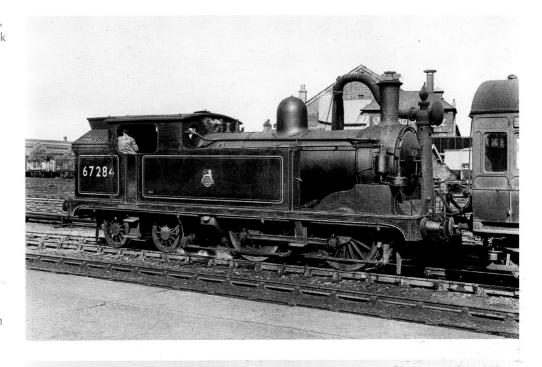

Saturday 30 July 1955 Seen here at Darlington station is push-pull gear-fitted ex-NER Class O (LNER Class G5) 0-4-4 tank No. 67284. Built at Darlington Works in 1896, she was fitted with the push-pull equipment in 1951 and would be withdrawn from service in 1956.

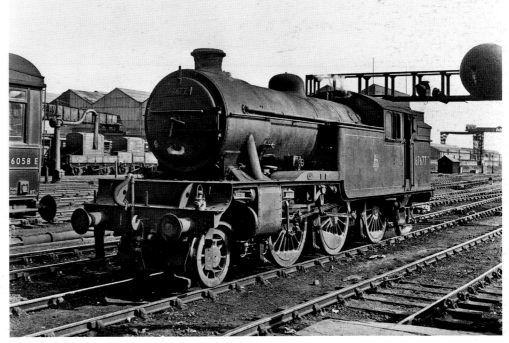

Saturday 30 July 1955 Ex-LNER Class V1 2-6-2 tank No. 67677 is also awaiting its next duty at Darlington station. Built at Doncaster Works in 1939, she would be rebuilt as a Class V3 in 1958 and withdrawn in 1962.

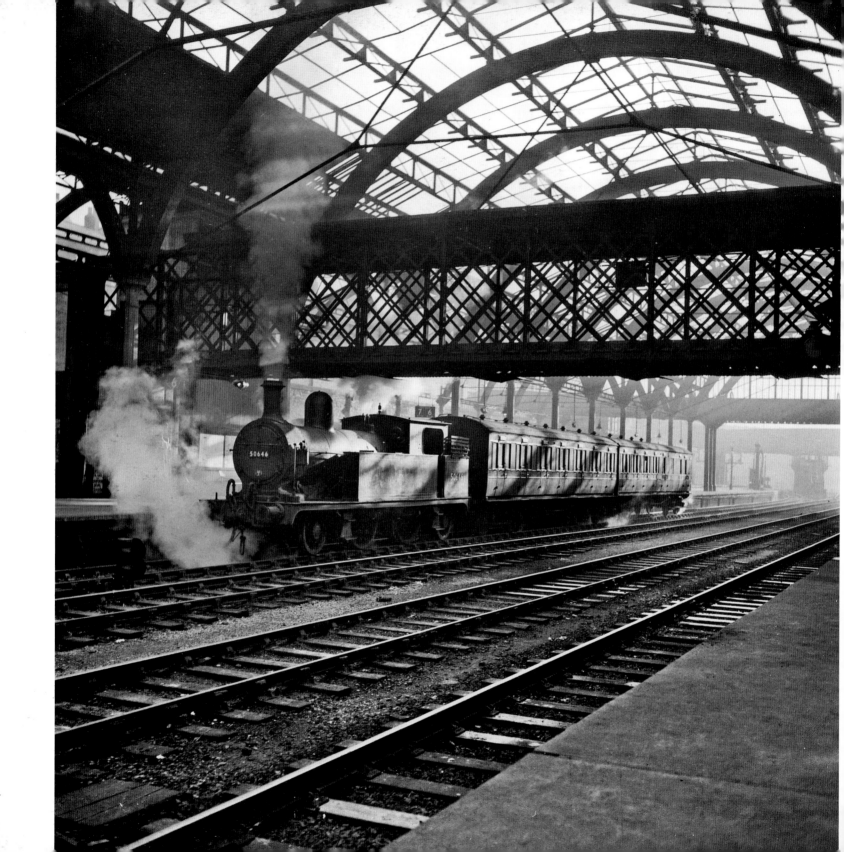

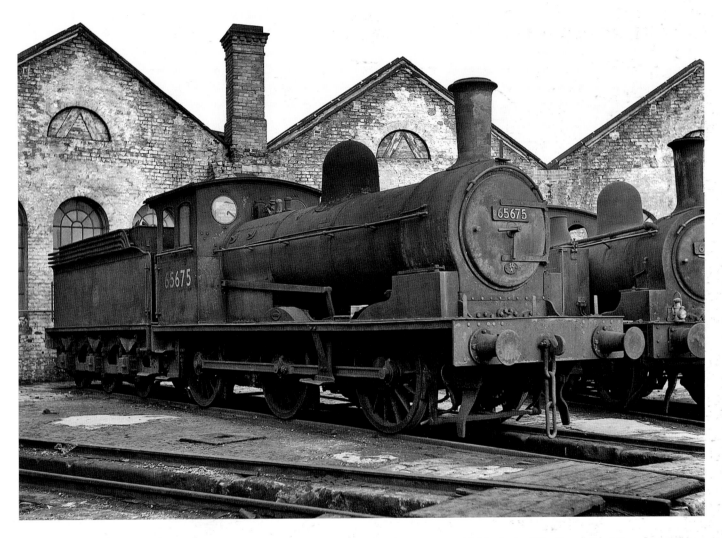

(Opposite) **Tuesday 15 November 1955** This wonderfully atmospheric photograph shows the interior detail of the roof structure at Sheffield Midland station. Ex-L&YR Class 5 (LMS Class 2P) 2-4-2 tank No. 50646 has just arrived with the 12.30 p.m. rail motor from Barnsley via Chapletown, which will return to that destination as the 1.30 p.m. departure. This veteran locomotive was constructed to a design of John Aspinall at Horwich Works in 1890 and gave sixty-eight years' service, before being withdrawn in 1958. The splendid overall roof at this station was damaged during the Second World War and finally removed in 1956.

Sunday 17 June 1956 Parked within the walls of the unroofed roundhouse at York shed is ex-NER Class P1 (LNER Class J25) 0-6-0 No. 65675. Bearing a York 50A shed code, she was constructed at Darlington Works in 1899 to a design of Wilson Worsdell that was introduced a year earlier. A total of 120 examples of the class were built at both Darlington and Gateshead Works, with twenty-eight examples incorporating superheating boilers. The example seen here was constructed with a saturated boiler and would give sixty years' service before withdrawal in 1959.

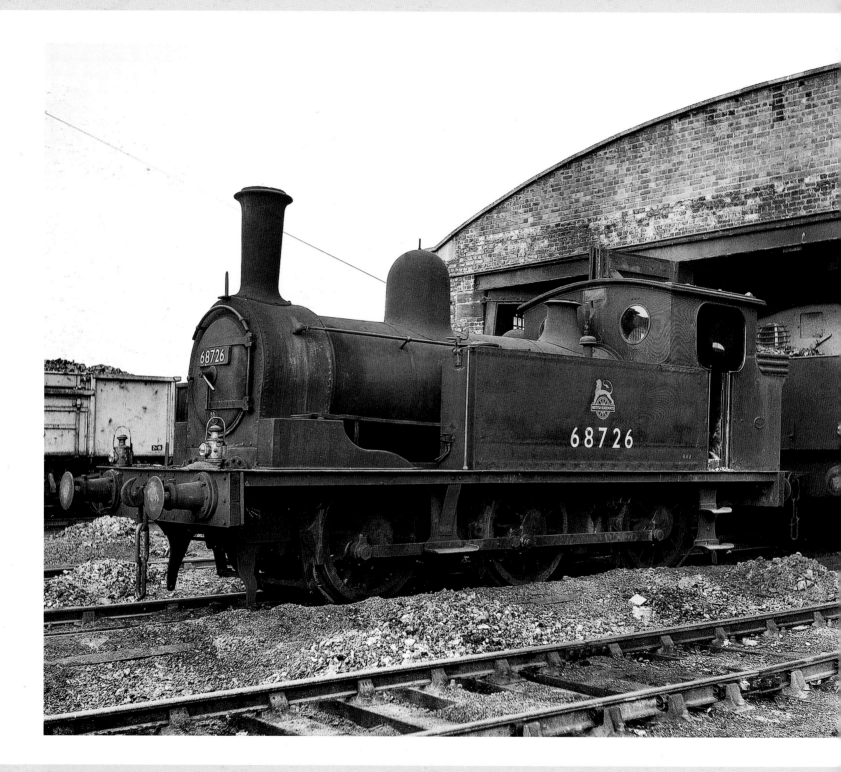

(Opposite) **Sunday 17 June 1956** Ex-NER Class E1 (LNER Class J72) 0-6-0 tank No. 68726 is seen here at York shed. Built by Armstrong Whitworth in 1922, she would be withdrawn in 1961.

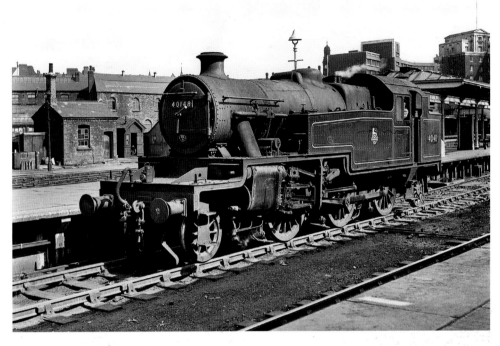

Tuesday 14 August 1956 Designed by William Stanier as an improved version of Henry Fowler's earlier design of Class 3P 2-6-2 tanks, the 139 examples of Stanier's tapered boiler locomotives were constructed at both Derby and Crewe Works. The example seen here at Leeds, No. 40148, was a 1937 Derby-built locomotive that would be withdrawn in 1962.

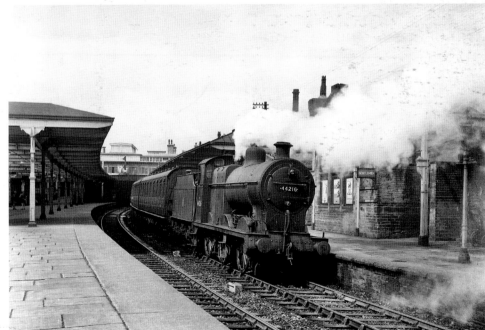

Tuesday 14 August 1956 Seen here at Keighley station working the 12.37 p.m. Skipton to Bradford Forster Square passenger train is ex-LMS Class 4F 0-6-0 No. 44216. Bearing a 20E Manningham shed code, she was a 1925 Derby Works-constructed example of this numerous class that would give forty years' service before withdrawal in 1965.

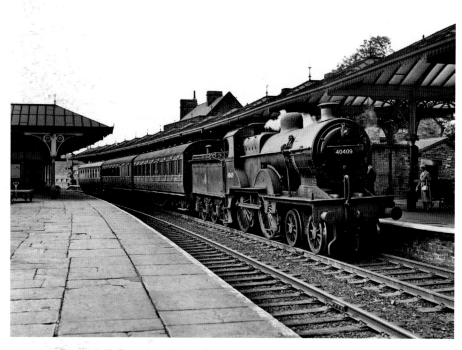

Tuesday 14 August 1956 At the head of the 12.22 p.m. from Manchester Victoria, ex-MR Class 2 (LMS Class 2P) 4-4-0 No. 40409 has arrived at its journey's end, Skipton station. Constructed in 1892, she would be withdrawn in 1957.

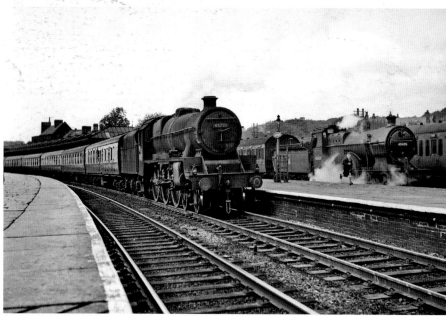

Tuesday 14 August 1956 Approaching the stop at Skipton station is the 10.05 a.m. departure from Edinburgh Waverley to London St Pancras passenger train. At its head, ex-LMS Class 5XP 'Jubilee' 4-6-0 No. 45729 *Furious* is in a filthy condition. Constructed at Crewe Works in 1936, she would be withdrawn in 1962. In the background, 4-4-0 No. 40409 is being ignored by a young enthusiast while he is running up the platform to photograph the 'Jubilee'.

(Opposite) Tuesday 14 August 1956 A busy scene at Barnoldswick station with the footplate crew of Class 2MT 2-6-2 tank No. 41327 filling the water tanks. The George Ivatt-designed locomotive was constructed at Derby Works in 1952 and would give only twelve years' service, to be withdrawn in 1964. The railway at Barnoldswick would not survive much longer: passenger services were withdrawn in 1966.

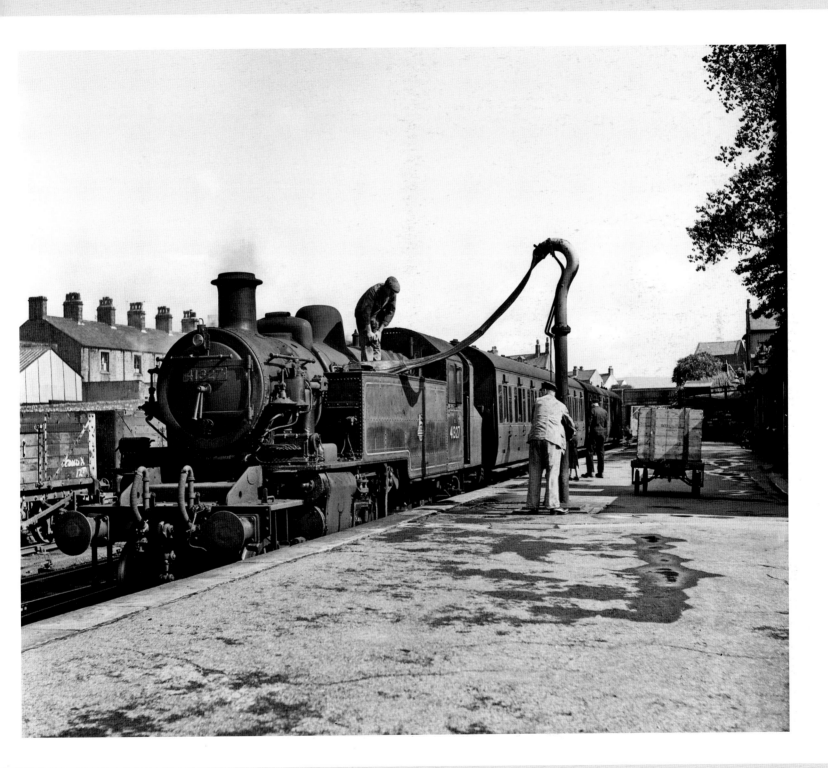

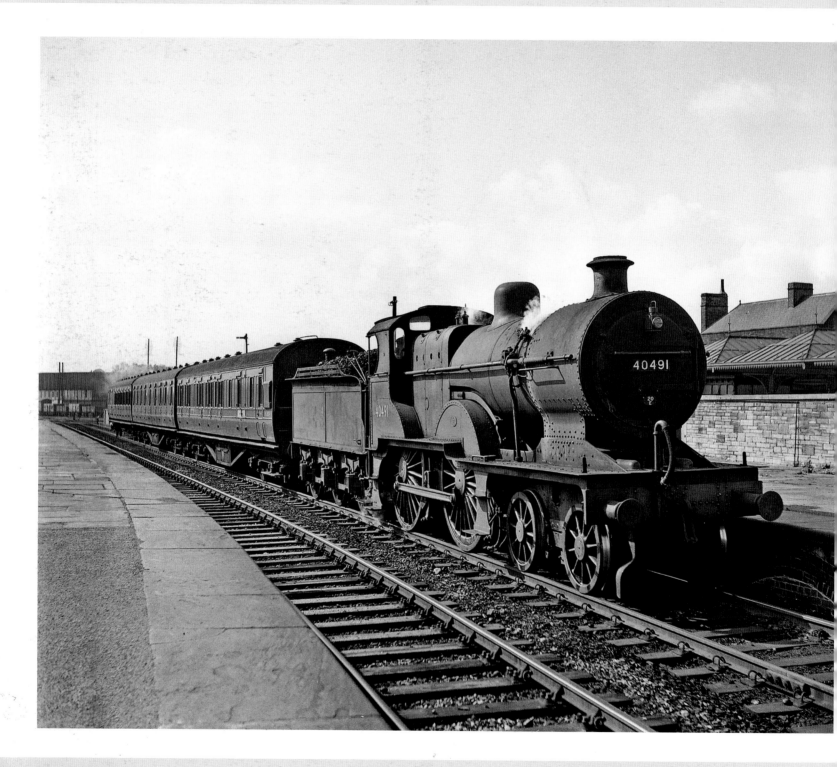

(Opposite) Tuesday 14 August 1956 Another ex-MR Class 2 (LMS Class 2P) 4-4-0 is seen here at Skipton station. No. 40491, bearing a 20E Manningham shed code, is waiting to depart at the head of the 4.45 p.m. passenger train to Bradford via Ilkley. A product of Derby Works in 1899, she would give sixty-one years' service before withdrawal in 1960.

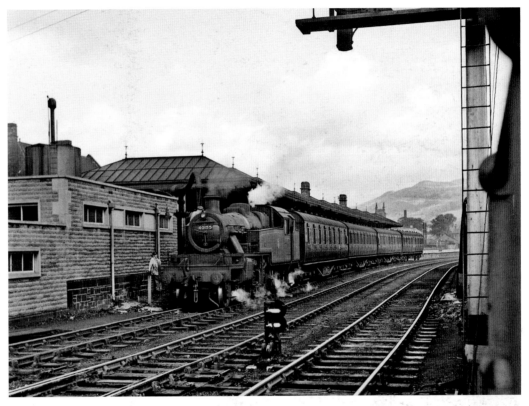

Tuesday 14 August 1956 Another scene at Skipton station sees ex-LMS Class 3P 2-6-2 tank No. 40155 taking water prior to departing with the 5.00 p.m. passenger train to Barnoldswick. Constructed at Derby Works in 1937, this locomotive would be withdrawn in 1962.

Tuesday 14 August 1956 Standing outside Ilkley shed is ex-L&YR Class 5 (LMS Class 2P) 2-4-2 tank No. 50795. A product of Horwich Works in 1898, she would give sixty-one years' service and be withdrawn in 1959. The impressive-looking shed was opened in 1892, but was closed in 1959.

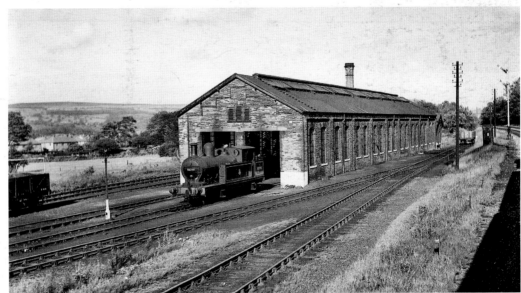

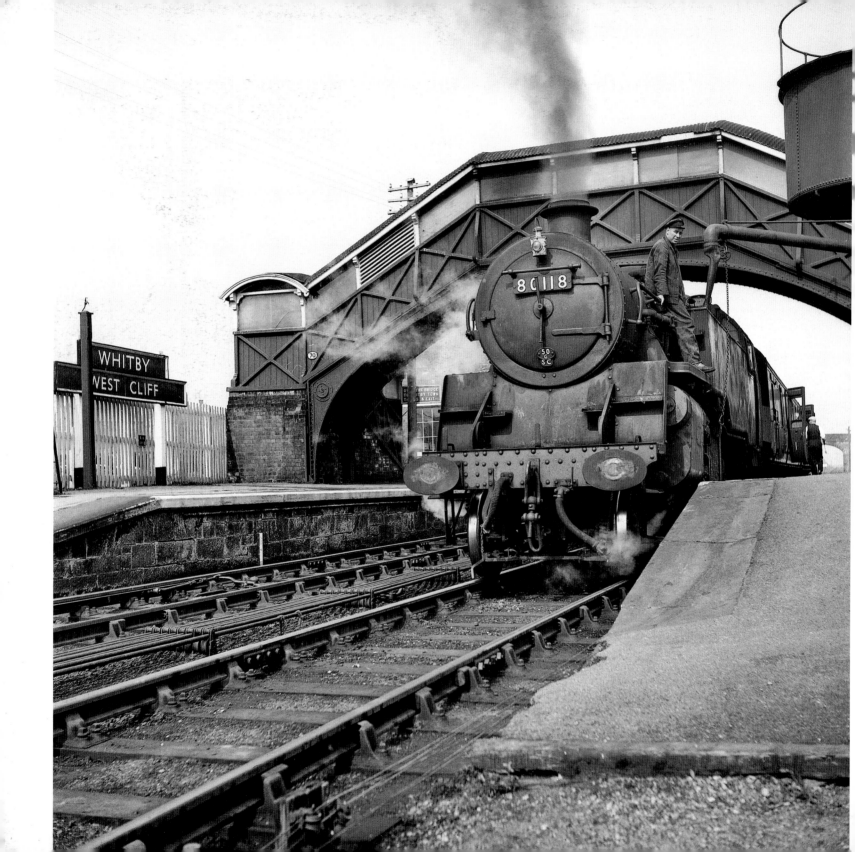

Thursday 1 May 1958 The three photographs on this spread show, for comparison, three classes of tank locomotives that were working around the Whitby area during this period. *Opposite:* Prior to the closure of the coastal route from Middlesbrough to Whitby Town via Staithes in 1961, locomotives would often take water at Whitby West Cliff station prior to the descent into Whitby Town station. Seen on this day, the fireman on British Railways Standard Class 4 2-6-4 tank No. 80118, bearing a 50G Whitby shed code, is managing this process while working the 9.25 a.m. Middlesbrough to Whitby Town service. Constructed at Brighton Works in 1955 and allocated to Whitby shed from new, this locomotive would later be allocated to Polmadie in Glasgow before withdrawal in 1966. *Right, top:* The fireman on Class 4 2-6-4 tank No. 42083 is clearly preparing for his locomotive's departure at the head of the 11.37 a.m. service to Malton. Bearing a 50G Whitby shed code, this locomotive was constructed at Brighton Works in 1951 to the design of Charles Fairburn for the LMS, being introduced in 1945. She would be withdrawn after only sixteen years' service, in 1967. *Right, bottom:* Edward Thompson's design of 2-6-4 tank locomotive, Class L1, is seen here at Whitby Town station in the form of No. 67765. Constructed at the NBL in Glasgow in 1949, she would only give thirteen years' service before withdrawal in 1962. A total of 100 examples of this class were constructed, the first appearing from Doncaster Works in 1945. It would be another three years before more examples entered service in 1948, with building continuing until 1950.

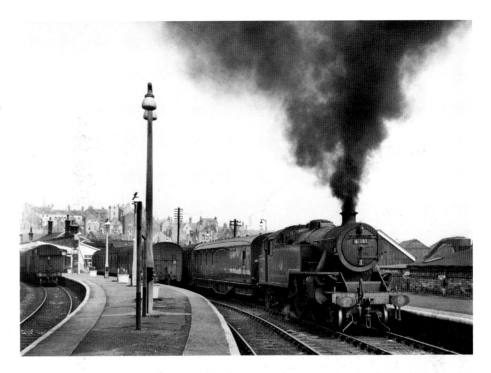

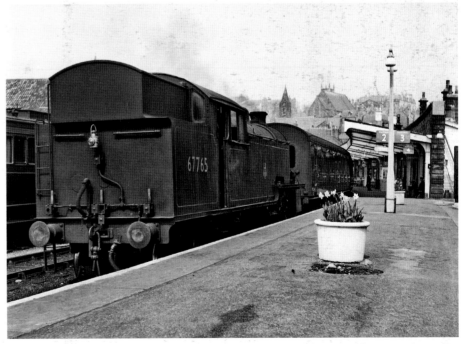

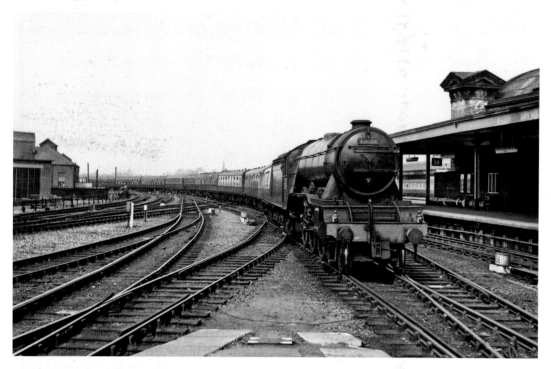

Thursday 1 May 1958 The three photographs on this spread show workings at York station. *Left, top:* Ex-LNER Class A3 4-6-2 No. 60069 *Sceptre* is seen arriving at the head of the 'up' 'Northumbrian'. Originally constructed by the NBL in 1924 as a Class A1 locomotive, she was rebuilt as a Class A3 in 1942 and would be withdrawn in 1962. *Left, bottom:* Another arrival at York is the 12.05 p.m. Newcastle to Manchester working, seen here behind Class A1 4-6-2 No. 60153 *Flamboyant*. Built at Doncaster Works in 1949, she would spend her entire working life allocated to York shed and only see thirteen years' service before withdrawal in 1962. *Opposite:* Seen standing below the magnificent station roof at York is ex-NER Class S3 (LNER Class B16) 4-6-0 No. 61429 at the head of the 2.12 p.m. passenger train to Leeds. Constructed at Darlington Works in 1921, she would be withdrawn from service in 1961.

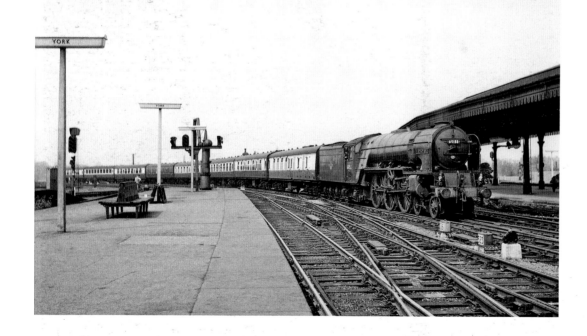

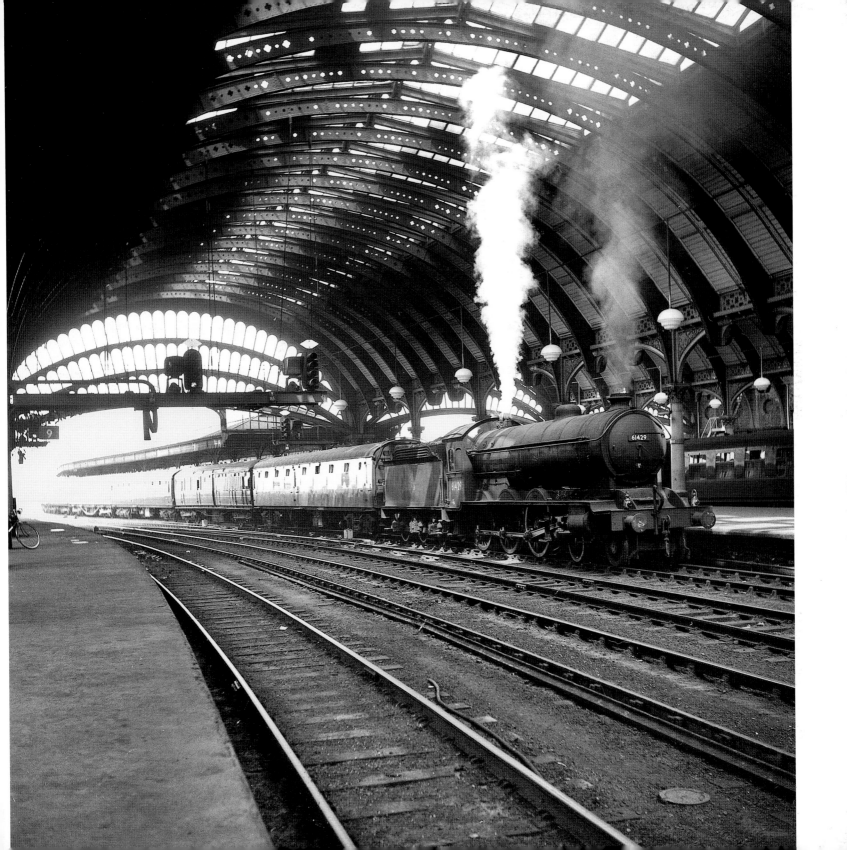

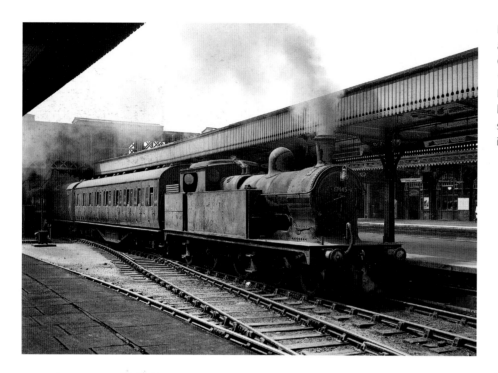

Friday 15 May 1959 The grimy atmospherics are apparent here at Sheffield Midland station with ex-GCR Class 9L (LNER Class C14) 4-4-2 tank No. 67445, which has just arrived with the 12.15 p.m. passenger train from Barnsley. Constructed by Beyer Peacock in 1907 as part of a class of twelve examples designed by John Robinson primarily to work the London Marylebone suburban services, she was destined to be withdrawn later in 1959.

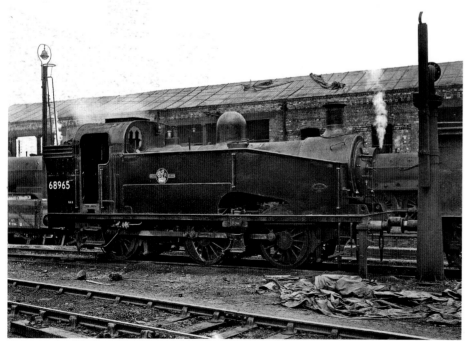

Sunday 30 August 1959 Standing in the yard at Doncaster Works is an example of an early Nigel Gresley design for the GNR. Ex-GNR Class J23 (LNER Class J50/3) 0-6-0 tank No. 68965 is looking in good external condition. Constructed at Doncaster Works in 1926, she would be withdrawn in 1963.

Sunday 16 July 1961 Seen here at Mexborough shed is an example of the Ministry of Supply order for the War Department (WD) of 935 locomotives produced between 1943 and 1945 by only two manufacturers, the NBL in Glasgow and the Vulcan Foundry in Newton-le-Willows. Ex-WD Class 8F 2-8-0 No. 90304 was a product of the NBL in 1944 that was numbered 77440 by the WD and saw service in France. Returning to the UK in 1947, she was loaned to the LNER until finally taken into British Railways service on Nationalisation. She would be withdrawn in 1964.

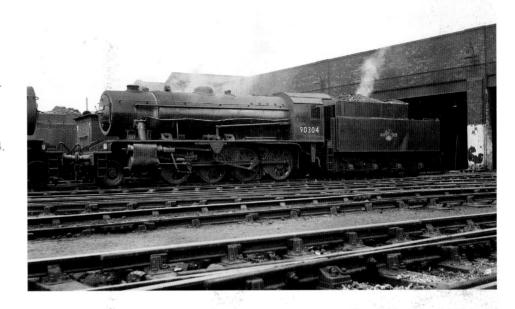

Sunday 16 July 1961 Sitting in the yard at Doncaster Works in ex-works condition is ex-GNR Class H4 (LNER Class K3) 2-6-0 No. 61906, bearing a 52H Tyne Dock shed code. Constructed by Armstrong Whitworth in 1931, she would be withdrawn in 1962.

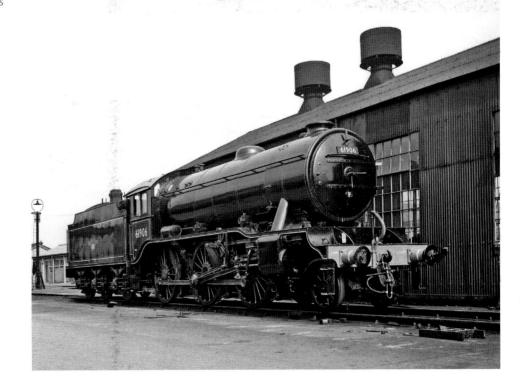

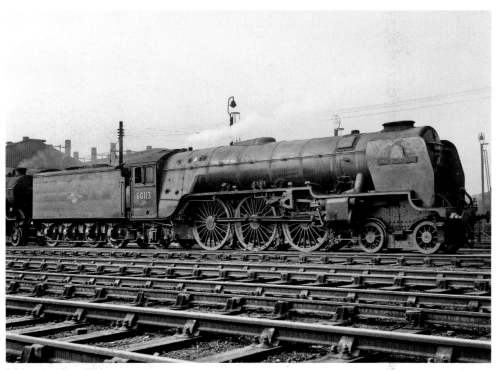

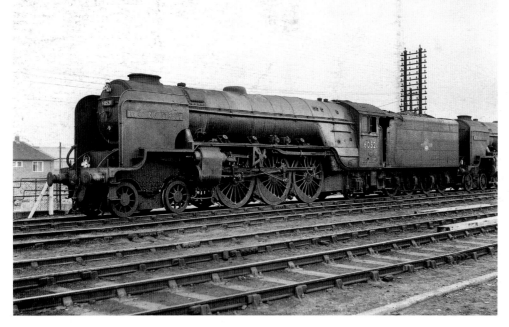

Sunday 16 July 1961 Seen here at Doncaster shed are three of the east coast 'Pacifics'. *Opposite:* Class A1 No. 60156 *Great Central* is looking especially clean. The final batch of ten locomotives of this A.H. Peppercorn design were constructed at Doncaster Works and entered traffic in 1949; all were painted in blue livery. It was not until July 1952 that the locomotive seen here acquired its name and the British Railways green livery. She would be withdrawn in 1965 after having given only sixteen years' service. *Left, top:* Class A1/1 No. 60113 *Great Northern*, formerly LNER No. 1470 later 4470, was Nigel Gresley's first 'Pacific' locomotive appearing from Doncaster Works in April 1922. She was used by Edward Thompson as the basis for the proposed rebuilding of the Gresley 'Pacifics' incorporating three separate sets of Walschaerts valve gear. She entered service in her rebuilt form in September 1945, without the smoke deflectors seen here, which were fitted later that year. Destined to become something of a wanderer, she was allocated to a variety of the ex-LNER sheds after rebuilding and would be withdrawn from service in 1962. *Left, bottom:* The last batch of Edward Thompson's Class A2/3 was completed in 1947 from Doncaster Works, and seen here is No. 60521 *Watling Street*. Named after the 1942 Derby winner, she would be withdrawn in 1962 after only fifteen years' service.

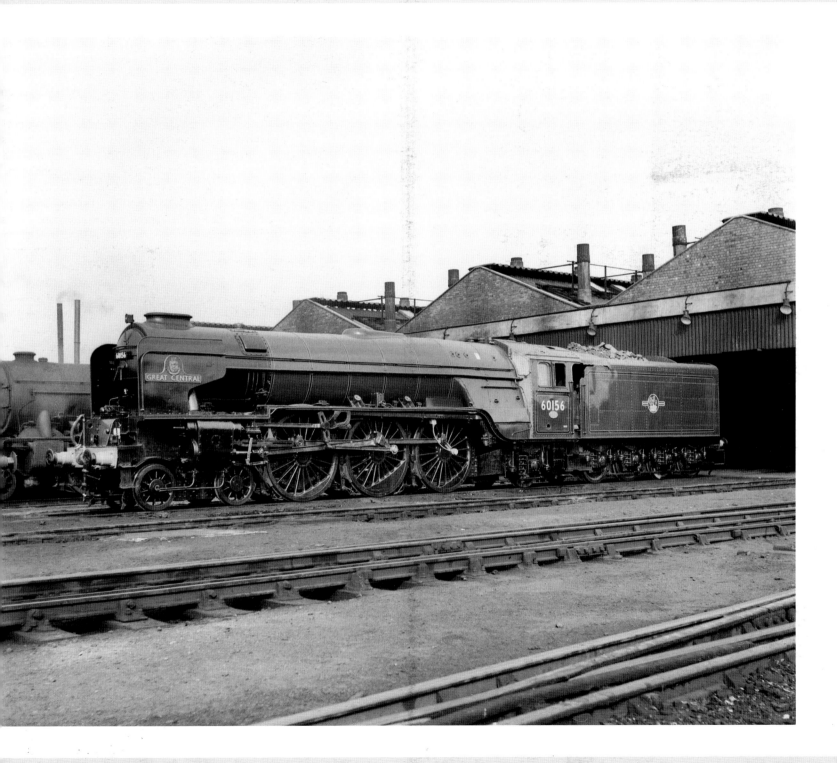

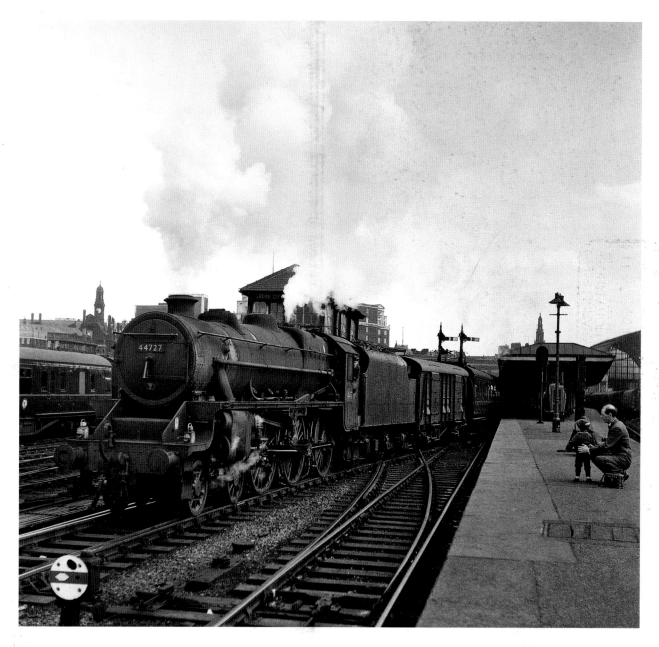

Saturday 4 May 1963 Seen here departing from Leeds station and passing Leeds City 'box at the head of the 10.20 a.m. Sheffield to Bradford passenger train is Class 5 4-6-0 No. 44727, bearing a 12A Carlisle Kingmoor shed code. One of a batch of ten examples constructed at Crewe Works incorporating a steel firebox in 1949, she would be withdrawn in 1967.